American Venus

American Venus

The Extraordinary Life

of Audrey Munson

Model and Muse

By Diane Rozas and
Anita Bourne Gottehrer

BALCONY PRESS • LOS ANGELES

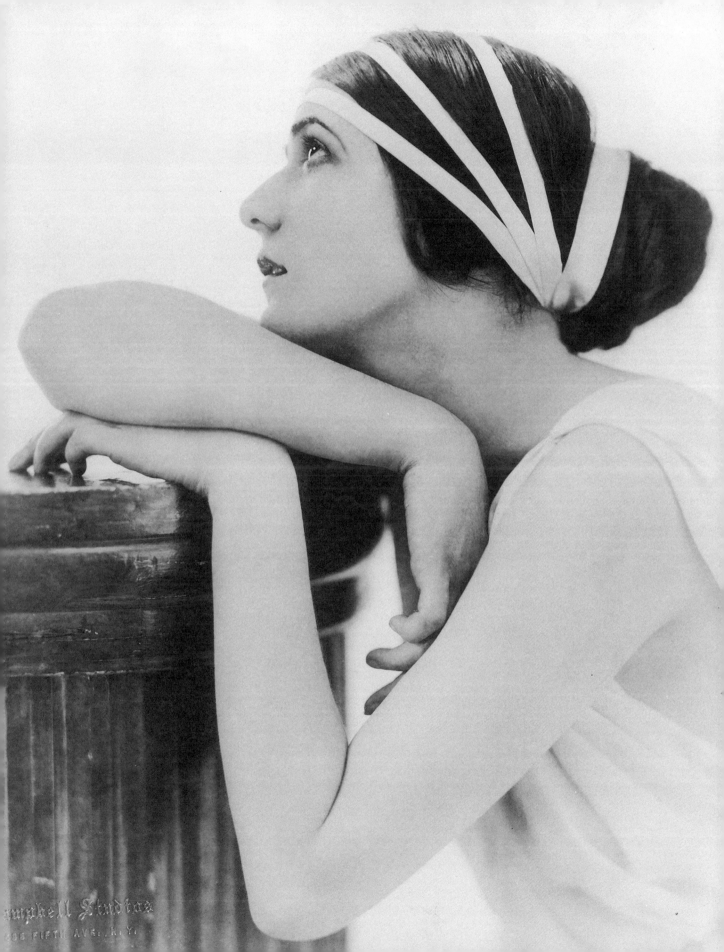

To the memory of

Audrey Marie Munson

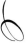

"*An artist's model who is intelligent, as all must be if they are to inspire such men as MacMonnies, Calder, French, Weinman, Bitter, Konti, Dodge, Aitken and Herbert Adams, learns a great deal about art and its uncertainties, its dreams and ideals and its disappointments as she passes from one studio to another in her daily work. From the temperamental painter, who is a great man one day and a naughty child the next, to the earnest, analytical sculptor, who is a cynic about women even while he idealizes them, the model learns art from all its perspectives. And the more she learns the more she is apt to ask herself in the privacy of her own room at night after a hard day's work: Just what is art, after all?*"

AUDREY MUNSON
1921

First Printing

Published in the United States of America 1999

Design by Agnes Sexty; Production by Jim Matcuk
Imaging and production by Navigator Press, Pasadena, California
Printed in Hong Kong
No part of this book may be reproduced in any manner without
written permission except in the case of brief quotations embodied
in critical articles and reviews.
For information address Balcony Press, 512 E. Wilson Suite 306,
Glendale, California 91206.

Library of Congress Catalog Card Number: 98-074949
ISBN 1-890449-04-0

TABLE OF CONTENTS

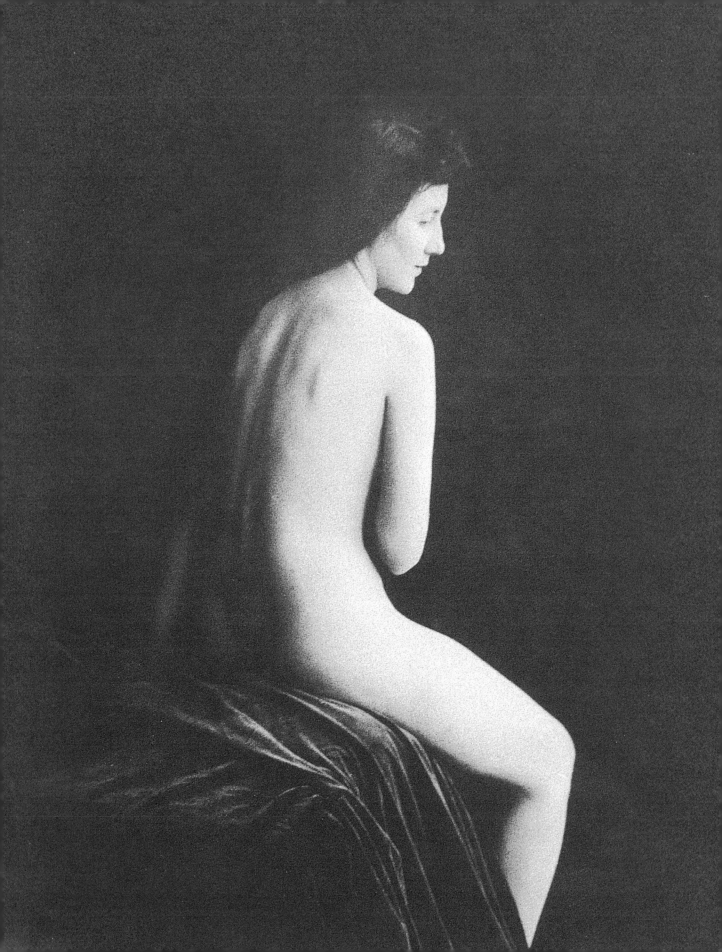

REDISCOVERING AUDREY

This book is the reflection of a journey we took tracing the dreams and images of Audrey Munson, an artists' model, a muse. Traversing time led us back to the early part of the 20th century when her story began. This period provides a rich and colorful backdrop for the life of a woman who made her dreams come true—but at great personal cost.

In reconstructing her life story we scoured museums and galleries, and called upon the descendants of famous Beaux Arts artists. We visited the artists' studios where she had posed eight decades before. We turned up long-forgotten newspaper clippings and vintage photos in dusty library morgues. Each detail in the newspaper articles took on great significance in identifying lost works of art. They also offered clues to her personality, her ideals, and the many paths of her career.

But the trail we discovered, the saga of her own experiences in the artists' studios, revealed that Audrey Munson was a woman who prized her work in the arts, and defended nudity in a time when most women still embraced Victorian morals, wore high-necked corseted fashions, and scorned the notion of work outside the home.

Most interesting in our search was the opportunity to meet and befriend people who possessed small bits of personal information about the mysterious Audrey Munson. A few precious hand-me-down sleeves from an old scrapbook became treasures in our hunt for the real woman of this story. Finally, when all the pieces of paper,

photos, files, and memorabilia were placed together, matched in time, they emerged as pieces of a puzzle. Hence, the many-faceted and sometimes fractured findings of Audrey's life are joined herein for the first time.

Uniquely, Audrey played an important role in the beautification of New York City and many other metropolises. As model and muse, her gift, born out of feeling, passion and deep inner imaginings, was molded in clay, carved in stone, cast in bronze, captured in paintings, tapestries, stained glass, in photographs and on moving picture film. Many works of art inspired by her poses are on display in public places even today. Therefore, her legacy endures in these works as symbols of her timeless muse—the embodiment of her inspiration, the vehicle of her expression. Many times, and in many cities, we visited the likenesses of Audrey with cameras in hand for the chance to welcome her back to the world of her dreams. These pages reveal, through contemporary and vintage images, her ever-present spirit where she stands today in sculptural form.

Audrey and her mother, her lifelong companion, left New York City and traveled until finally returning to the world of rural upstate. Because Audrey Munson never had a family of her own there was no one to pass along the intimate side of the triumphs and tragedies of her energetic, enthusiastic, imaginative, and above all, enigmatic existence. Coincidence, timing, and serendipity kept pushing us forward. We began to feel that this story's time was due, and we had become its tellers. Previously, hers was a story of anonymity and forgotten fame. Now she can be praised publicly once again.

If this book leads you to pause by a work of art for which she posed, then our purpose, and Audrey's muse, will have been well served.

New York Public Library, Frederick MacMonnies sculptor.

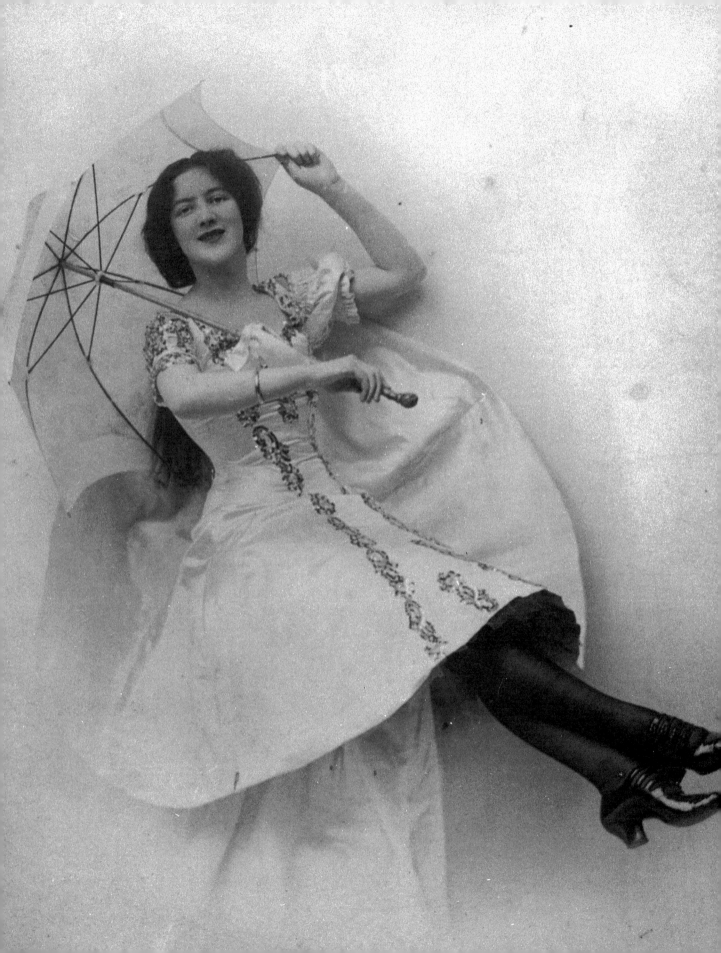

The Early Years

1891-1906

✳ *Americans hummed "Boola Boola," tapped their toes to Scott Joplin's "Maple Leaf Rag," and marched down Main Streets to John Phillip Sousa. • In Alaska and Colorado Gold Rush miners became overnight millionaires. • The advent of the zipper revolutionized fashion, women's skirts rose an inch above the ankle, and Vogue joined Bazaar and Ladies' Home Journal as harbingers of good taste. • People were reading Mark Twain, Walt Whitman, Oscar Wilde, and Edith Wharton. • Lautrec and Gaugin redefined art in Paris while Frank Lloyd Wright reinvented architecture in the American Midwest. • Hershey's chocolate and Wrigley's gum became popular. • In Kansas, the Dalton brothers were shot while robbing a bank. • In Buffalo, New York, at the Pan-American Exposition of 1901, President McKinley, was struck down by an assassin's bullet. • Six days later, Teddy Roosevelt carried his big stick into the White House.* ✳

AUDREY MARIE MUNSON was born on June 8, 1891 in Rochester, New York. Before she was 20 she would become one of the best known women in Manhattan as model and muse to the most famous sculptors of the early 20th century.

As a girl, Audrey had dreamed of studying music and dance in far off Manhattan. She talked of one day teaching young children the songs she loved to sing, along with dancing and playing the piano. At the private Catholic school of arts she attended in Providence, Rhode Island, her talents were nurtured from a young age.

It was in Providence that Audrey first entered the world of theater, performing in summer at the Rocky Point amusement park with the "Dancing Dolls." Around this time Audrey first posed for a local photographer. Already a striking girl, she modeled as a Venus, a Victorian coquette, a water nymph, and a gently draped Diana.

Katherine Mahaney and Edgar Munson's marriage had ended in divorce. Though Audrey was always her father's beloved daughter, five new half-siblings would call him father, too. Off on their own without Edgar, where would the Munson women call home in the conservative world of rural upstate New York? Perhaps the reason Katherine had taken young Audrey to a gypsy fortune teller was to help chart their future. For the beautiful young girl, the gypsy predicted fame and fortune, as well as many lovers, "Seven in all, the last one she would wed." The gypsy also predicted Audrey would lose it all, though Katherine likely chose to ignore this latter prediction.

With hopes high, the Munson women moved to New York City. They were ordinary folk from rural upstate and probably rode the local train to Syracuse, boarding the second-class coach for New York, a city of great import and wealth. A beautiful divorced woman, Katherine surely viewed the move as a chance to start over in life. Audrey, an unspoiled teenager, might have thought of it as an adventure where her most precious dreams might come true. Katherine found work in a corset shop, earning a meager income while Audrey waited for music school to begin in the fall. The year was probably 1906.

A rare reminder of Audrey's childhood. She got this souvenir glass from the 1901 World's Fair in Buffalo, New York. Audrey would have been 10 years old.

AUDREY'S DISCOVERY.

Of course, they didn't know what would transpire in their lives over the next decade but fate would step in almost immediately. It is uncertain whether Katherine realized the appeal of her lovely daughter's charms and fertile imagination. Soon Audrey would learn to look to her inner world for the passion and knowledge she needed to give herself to her modeling assignments. Audrey recounted her discovery:

"Mother and I were walking downtown shopping. A man kept following me and annoying me, not by anything he said but by looking at me. We even went into a shop to get rid of him, but it was impossible, and finally Mother stopped, turned to him and asked him what he wanted. He explained he had not meant to annoy me, but that he was a photographer and said my face was one that he longed to photograph. He asked mother if she would not bring me to his studio. At first she refused, but he pleaded so hard that she finally said she would. We went; he took many pictures. Then he called one day and asked if he might show them to an artist friend, and tell him who posed for them. We did not refuse; the artist then asked me to pose, and that was the beginning."

It was Ralph Draper, a portrait photographer, who created the first professional images of Audrey. Indeed, he was the one

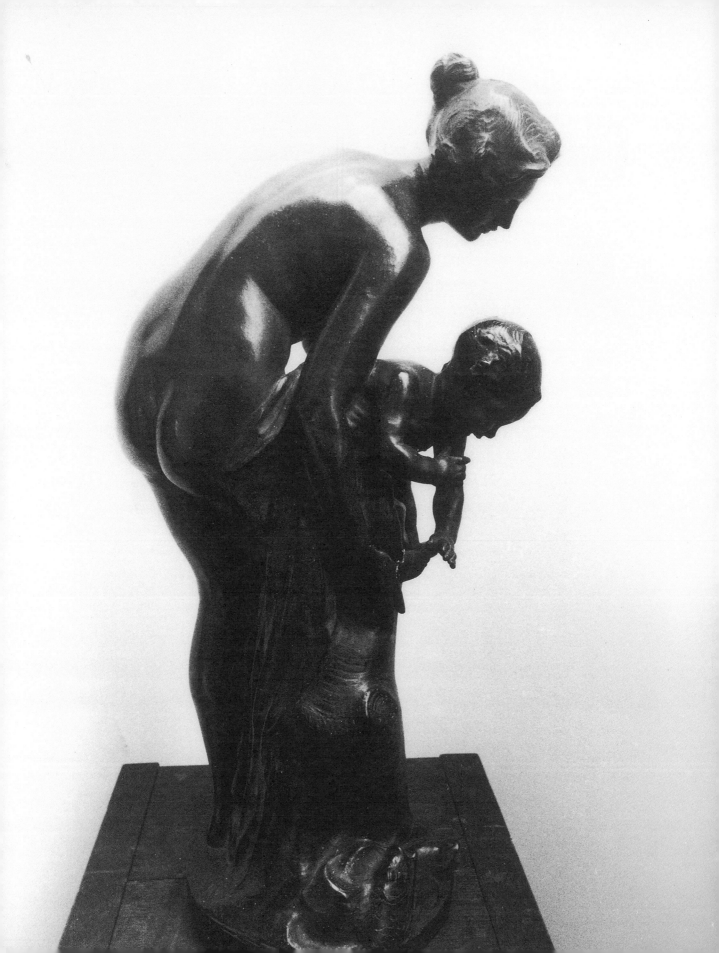

who first noticed her yet-undeveloped appeal to the artists' eye. Draper showed the photographs to his friend, the Hungarian born sculptor, Isidor Konti. From this fateful meeting on the street in Manhattan, Audrey's career as artist's model began under the tutelage and care of the gregarious and warm hearted Konti. Despite Katherine Munson's objections, it was also Konti who first persuaded the hesitant teenager to pose nude. Audrey was not yet 16 years old.

The professional collaboration that developed between Konti and Audrey Munson contin-ued for many years. Her inspiration would result in some of Konti's best known works, such as the serene "Mother and Child" now in the private collection of Richard and Lydia Kaeyer.

But You Will Have to Pose in the Altogether.

Audrey recounted her first meeting with Konti: *"Mr. Konti said at first that he did not need a model, but had me, with my Mother, remain to have tea with him. Suddenly he rose from the table, walked about me, asked me to stand and walk, and then said he thought he could use me—that he had an unfinished work on which he had been engaged for three years but never completed because he had not found the proper model.*

"But," said Mr. Konti, "you will have to pose in the 'altogether.' The subject is one which will depict your entire form, not only one pose, but three....To us it makes no differ-ence if our models are clothed or draped in furs. We see only the work we are doing."

The result—a beautiful composition, the "Three Graces" which stood in the lobby of the elegant Hotel Astor. Audrey later referred to this work as "a souvenir of my Mother's consent." The professional collaboration that developed between Konti and Audrey Munson would continue for many years. Her inspiration would result in some of Konti's best known works, such as "The Three Muses," the serene marble "Mother and Child," "Pomona" (which Konti completed for renowned sculptor Karl Bitter after his untimely death), and as the female figures within the groupings on the monumental "Column of Progress" created for the 1915 Panama Pacific International Exposition.

HE CAST HIS SCULPTOR'S EYE UP AND DOWN HER FIGURE.

With an introductory letter from Konti, Audrey arrived at the 10th Street studio of the esteemed artist Adolph A. Weinman. His career was shaped by the brilliant Beaux Arts sculptor Augustus Saint Gaudens. One of America's most honored and prolific sculptors and the designer of several U.S. Mint coins, the German-born Weinman was an intimidating figure for any young woman. She was just four months past her

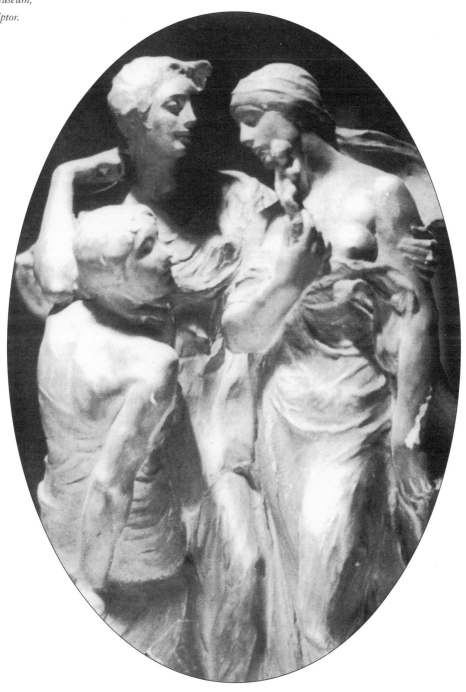

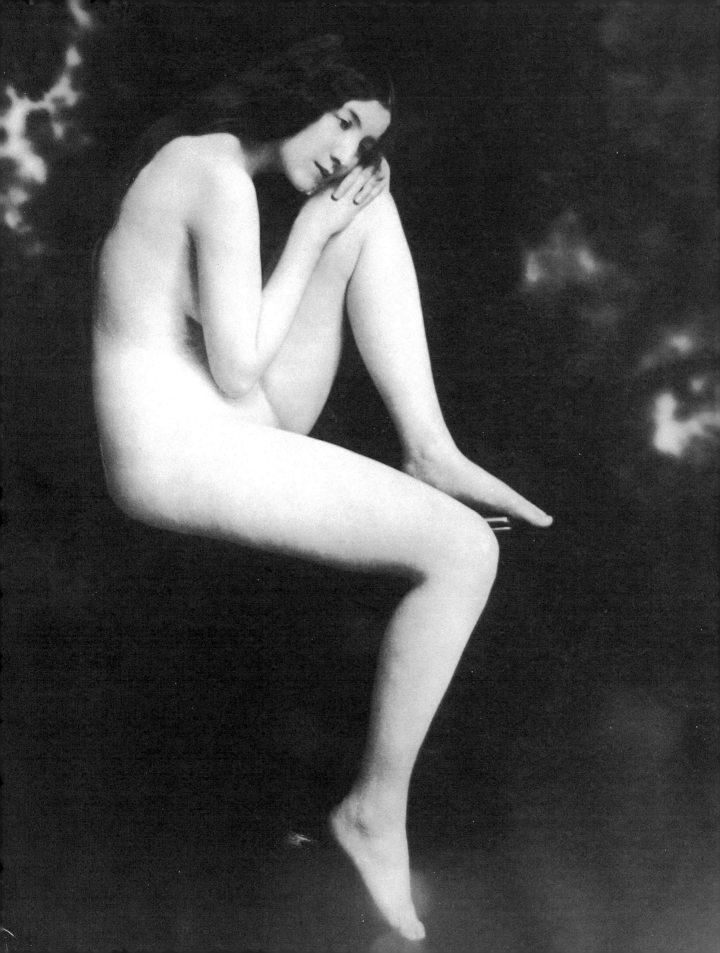

sixteenth birthday and still naive in the way of the artists' studios. He admitted her to the studio and, while chatting with her to ease her nerves, he cast his sculptor's eye up and down her figure. He noticed her slim, though shapely, form. Audrey, at Weinman's request, went to the shaft of north light from the window and began to turn and walk about. The conversation was later recalled by Audrey in this way:

Weinman remarked, "Well, you look as if you should pose all the time. You are quite Grecian, and yet you seem to have the warmth of motion the modern public likes to see in its models. I might use you, I want a model for some work I am finishing right now. Let's see what you look like.

"Don't you know what I mean?" Weinman said, brusquely. "Do you think I can tell anything about a woman with her clothes on? I don't want to see your dressmaker's art, I want to see what nature did for you. Get your clothes off!" the artist demanded, leaving no time for shyness from his prospective model.

There was a screen across the open door into the little dressing room for models. He indicated this screen with his hand. I went into the room—just a closet with a mirror and a dressing table and a chair. I was brave enough while taking off my clothes, and got them off in a hurry. I was brave enough, too, as I stepped forward into the space hidden from the studio room by the screen.

Then all at once my courage left me. I was completely nude—an artist does not allow a model to appear for inspection with even so much as a slipper on. And here I was about to step out in front of a strange man— who would stand me in a blare of light while his eyes roved over me in silent criticism.

I started to step out from behind the screen. My nerve gave way, and I trembled and stepped back again quickly. Twice I nerved myself to the task, and each my feet failed me—I didn't think I could do it. Mr. Weinman became impatient. He said, "Come, hurry up, I haven't time to waste, you know!"

He was very brusque, although I learned afterward he was very gentle and kind at heart. I then tossed my head, squared my shoulders, bit my lip and decided to "brazen it out." After all, I argued, I am just a model, just so many pounds of flesh and blood. He will not be scanning Audrey, the girl—but just a girl, the model.

One bare foot stepped out boldly. Then I wilted again, but it was too late. One foot was outside the screen and he had seen that I was coming. I had to go on. But all my daring and firmness was gone. I could only bring my other foot up to where my first one was—which brought me clear outside the screen. And there I stood, shamed and afraid, my head hanging down and my hands clasped nervously in front of me. Almost as soon as I was clear of the screen and while I was waiting and trembling, my head hanging, my hands clasped before me

and they pressed against my body, he called out excitedly. Weinman said, "There—stop—just as you are—hold that now. Put up your hands—slowly—don't move the rest of your body—get the hands up—over your head as if you were fixing your hair—there—never saw anything like it. Hold it. Don't budge!!"

He flung out the quick, staccato-like commands like the shots from a pistol, but there was that in his tone that stirred me. It was approval, interest, eagerness, something appreciative I had inspired in him. I waited breathlessly, holding the pose.

It seemed like an eternity—it was really about thirty minutes—I stood there, not a muscle moving, not even my eyes wandering.

My arms began to ache, my legs to waver. He saw it almost instantly. Throwing down his charcoal and springing up from his chair he came over to me, saying, "Forgive me for keeping you in position so long. I was so interested I forgot. But you gave me an idea—a great idea—that pose of yours. It was splendid—so natural!"

And "Descending Night" grew into a wonderful thing of grace and marble and won for the sculptor a highly-prized medal and was bought for the city of New York by its Metropolitan Museum.

Weinman's ethereal statue, "Descending Night," so perfectly embodying feminine grace and fragility, held a position of high honor on the center column next to her masculine counterpart "Ascending Morn" at San Francisco's Panama Pacific International Exposition in 1915.

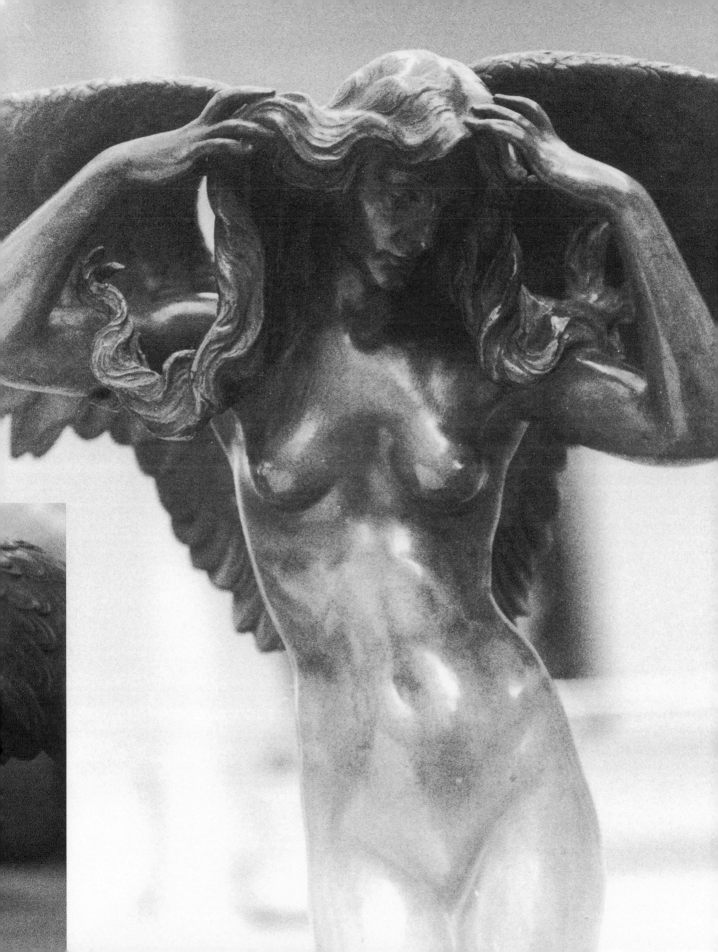

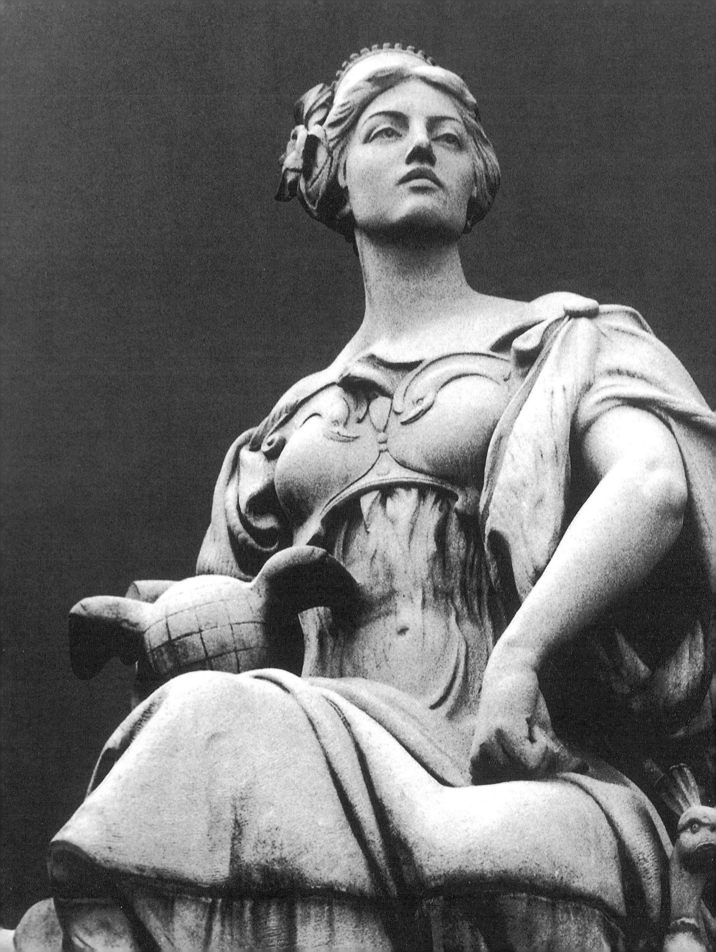

MISS MANHATTAN

1906-1915

America sang such favorites as "You're a Grand Old Flag," and "By the Light of the Silvery Moon." • Ziegfield staged his first "Follies" at Broadway's newly-opened and extravagantly decorated Amsterdam Theater. • European dance sensation Isadora Duncan performed barefoot, wearing only a diaphanous dress, on an empty stage at the Metropolitan Opera House. • Visionary artist, Alfred Steiglitz, proclaimed photography to be one of the great art forms. • A woman in New York was arrested for smoking in public. • In Pittsburgh, the first nickelodeon opened…and…America was stunned by the news…the Titanic had sunk. • People were duly shocked and confused by Cubist and Impressionist art at Manhattan's Armory Show. • The Government formed the FBI. • Off the assembly line rolled the first Model-T Ford, priced complete at $500. • The war in Europe raged on and caused the closing of the New York Stock Exchange for six months.

AUDREY'S CAREER flourished, and she reached the height of celebrity. Affectionately, by the artists, she was dubbed "Venus of Washington Square," and by the press, "Miss Manhattan."

"One hundred artists claim that if the name of Miss Manhattan belongs to anyone in particular, it is the young woman with the laughing eyes, smooth, sleek hair and features that lend themselves to everything from the blessed damsel to a floating dancing girl."

—THE SUN, 1913

The girl with the dream of singing and dancing applied her talents to her new career, impressing many artists with her inspired poses, cooperative nature and professional attitude. In nine years of dashing from studio to studio Audrey Munson earned the attention of the press which frequently hailed her as muse and inspiration for many highly visible works of public art. In an article that labeled her "Miss Manhattan," she was said to have posed for more decorative civic art commissions than any other model.

In 1913 *The Sun* wrote of her ubiquitous presence: "Do you remember the work of A.R. Wenzel over the proscenium arch of the New Amsterdam Theater—the riot of graceful figures? Miss Munson was the model chosen for this work and in one of the figures her portrait is almost exactly given.

"Up on top of the Municipal Building stands the figure of "Civic Fame." made by Adolph Weinman. There Miss Munson is again, while down on the Custom House she is to be found as many of the pieces of work.

"In the Hotel Astor, Isidor Konti's 'Three Graces' were all made from Miss Munson. Up on Riverside Drive Allen George Newman's fountain "Music of the Water," shows another pose of this young woman. Outside the Little Theater the figures on the tablet were made from her by Mr. Heber, and Robert Aitken used her for the finishing of the figures in the doors of the tombs of Mr. Greenhut and John W. Gates. James Francis Brown has made many decorations in which he has posed Miss Munson, and his "Darkness and Dawn" is soon to hang in the grill of a new hotel."

ALL NEW YORK BOWS TO THE REAL MISS MANHATTAN

Audrey Munson, Who Tops the Municipal Building as Civic Pride and Decorates Other Parts of the City in Various Guises, to Typify New York Femininity on Manhattan Bridge

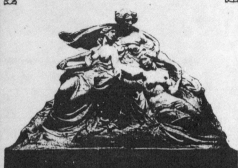

"The Three Graces" By Isidore Konti, Posed by Miss Munson

Miss Audrey Munson

Miss Munson as Autumn

Fountain on Riverside Drive by Allen George Newman

In The "Spirit of Commerce" Group by C. A. Heber, Manhattan Bridge

Miss Munson "Miss Manhattan"

Miss Munson as Spring.

Caution Before About Flies.

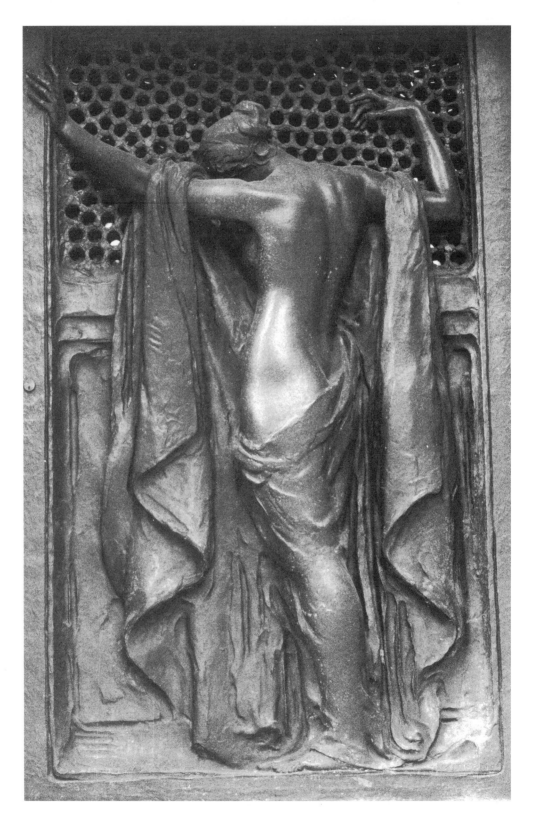

Bronze door, Robert Aitken sculptor.

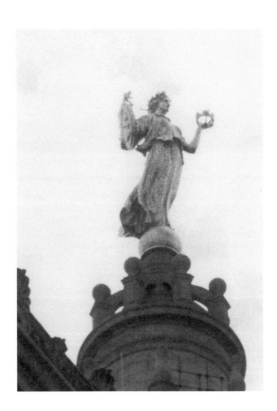

"Civic Fame" by Adolph Weinman atop the Municipal Building in Manhattan was the largest sculptural piece in the city when it was erected. The twenty-foot high gilded figure of Audrey Munson still gazes out over the city of New York and all its adjoining boroughs.

Beaux Arts in America.

At the end of the Civil War, eager workers began to build up America's industry and railways. Commerce, communication and transportation boomed as the West was developed and the two coasts were joined. An American aristocracy that was based solely on wealth emerged. Many of these wealthy industrialists resided in New York City.

These truly wealthy families, with names like Vanderbilt, Astor, Frick, Whitney and Rockefeller, chose to display their fortunes by building mansions along glamorous 5th Avenue—a gas-lamp lit and evenly-cobbled way. Here, beautifully endowed aristocrats isolated themselves from the world of the immigrants—tenements replete with strug-

gle and illness just blocks away. Living in this splendid microcosm of the well appointed literally meant their feet never touched the pavement. And if they did, upon arriving at their 5-story, 20,000 square foot palatial homes, a servant would be waiting to wash the bottoms of their shoes.

A desire to emulate the European decorative arts and styling at home created demand for respected artists and skilled craftsmen. The wealthy—less patrons of the arts than earnest consumers—commissioned everything from the architecture for their town villas and vacation estates to the furniture, carpets and fabrics that would embellish their interiors. Even more important were the works of decorative and fine

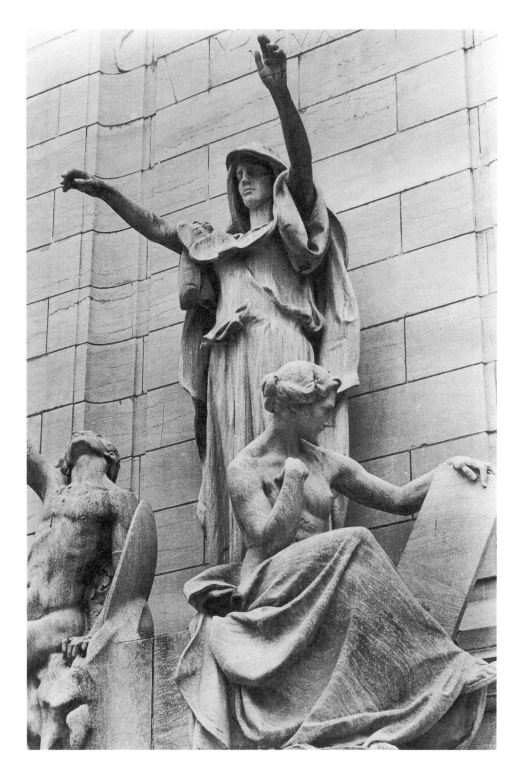

Detail from monument to the battleship Maine.
Columbus Circle, New York City.
Attilio Piccirilli sculptor.

art which included paintings, sculptures, and garden fountains. For these, they summoned their favorite artists. Thus, the Beaux Arts movement in America blossomed.

At the turn of the century, Manhattan joined with its surrounding boroughs—Brooklyn, the Bronx, Queens and Staten Island—in order to establish New York City as the largest city in the world. To commemorate this magnificent claim, and to create a city as beautiful as any of the great European capitals, huge sums of municipal money were allocated for decorative works of public art. The Municipal Art Society, along with many other social and cultural societies, was formed to administer the money and assign commissions. Artists competed for the privilege of creating these important civic monuments in stone and bronze.

Munson posed for the figures on top and at the base of this enormous memorial.

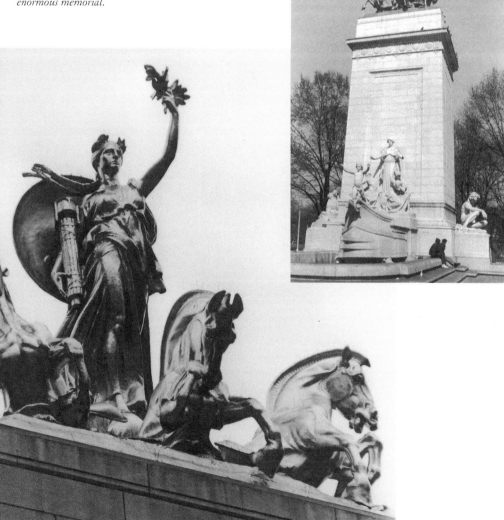

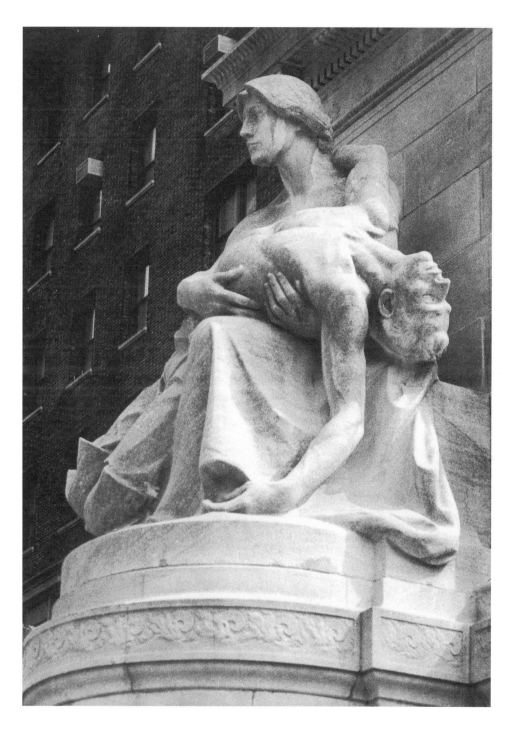

ABOVE & PREVIOUS PAGE
Firemen's Memorial, New York City.
Piccirilli Family, sculptors and stone cutters.

To service the insatiable needs of the wealthy patrons and the civic art commissions, a breed of prosperous, socially connected "gentlemen and women artists" emerged. Leagues and societies for sculptors, painters, designers and artisans formed. Successful, intelligent and very well paid, they established vast art studios and employed scores of assistants, including professional models. These models, male and female, catered to an art scene exploding with job possibilities. Rushing from studio to studio for an eight or nine hour day of posing, they received about fifty cents an hour for their challenging work. Some would command a higher price as their popularity among the artists grew. Since many of the commissioned works were figurative in nature, most artists preferred to work directly from nude flesh for their initial sketches or clay maquettes. The art and architecture of classical Beaux Arts styling demanded sculptural decorations and figurative details and, for every figure, a live model was required.

Audrey's arrival upon the art scene at this time seems almost fated. Her success was no surprise.

Weinman, Konti, French, Karl Bitter, Attilio Piccirelli, Robert Aitken, Evelyn Longman and others were among the pantheon of Beaux Arts talents in the city. In order to obtain the commissions, the artists supplied illustrative plans and maquettes of their ideas made directly from living models. It made sense that these artists shared their models, and surely they discussed amongst themselves the particular merits and attributes of the different "posers." Though Konti claims to have discovered Audrey, she worked in many studios, giving all the artists the opportunity to believe he (or she) had discovered some special attribute of hers that no other artist could discern. It is certain that Audrey actually inspired many of the works for which she posed.

Many of the important commissions assigned in Manhattan between 1906 and 1915 still remain today on major civic structures: the Custom House, the Municipal Building, the New York Public Library, and many more. These complex and costly commissions could include dozens of sculptures with groupings of allegorical figures, friezes, and larger-than-life size giantesses and giants striking idealistic poses. Often, the works represented lofty concepts such as Civic Pride, Commerce, Truth, Beauty, History, and the Continents of the World. Memorials, too, were some of the most important commissions of the day. Usually paying homage to the noble and selfless, such monuments were dedicated to firemen, the battleship Maine, the victims of the Titanic, as well as personal memorials for the tombs of those who could afford such somber luxuries.

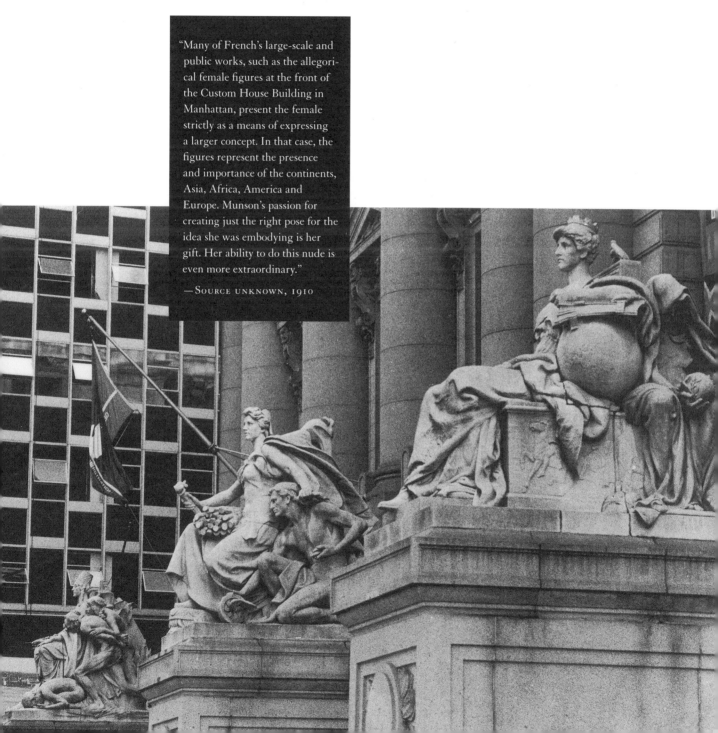

"Many of French's large-scale and public works, such as the allegorical female figures at the front of the Custom House Building in Manhattan, present the female strictly as a means of expressing a larger concept. In that case, the figures represent the presence and importance of the continents, Asia, Africa, America and Europe. Munson's passion for creating just the right pose for the idea she was embodying is her gift. Her ability to do this nude is even more extraordinary."

—Source unknown, 1910

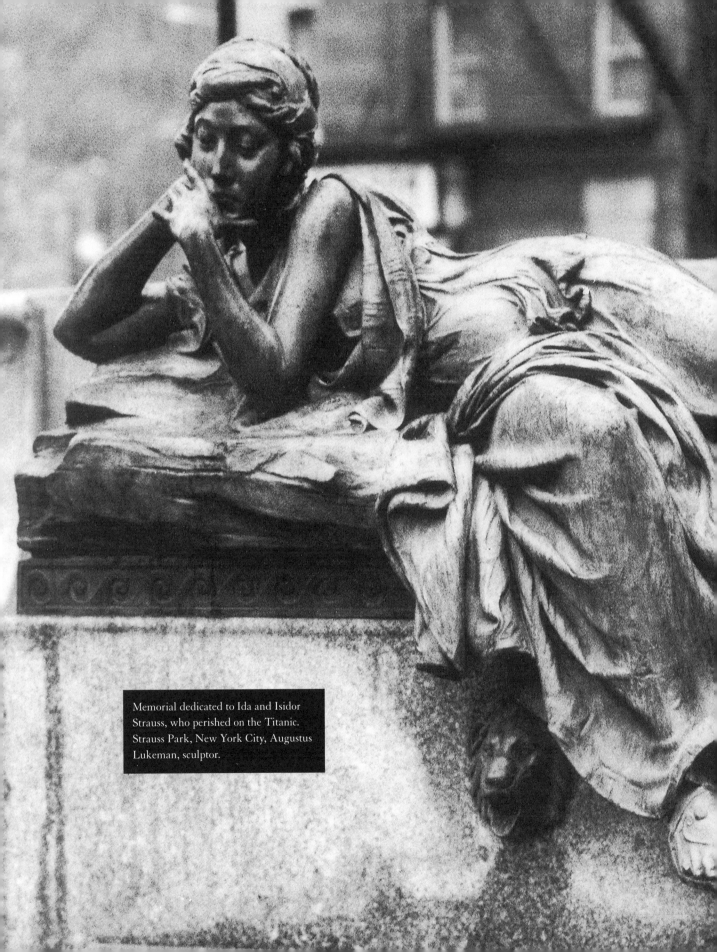

Memorial dedicated to Ida and Isidor Strauss, who perished on the Titanic. Strauss Park, New York City, Augustus Lukeman, sculptor.

Only an inspiring model, a "muse," could infuse these symbols with the deep emotion required for posthumous public remembrances. Audrey Munson was such a model—beneath her flesh a muse dwelled. And for its release, Munson would pose draped, clothed and naked again and again in the name of fine art.

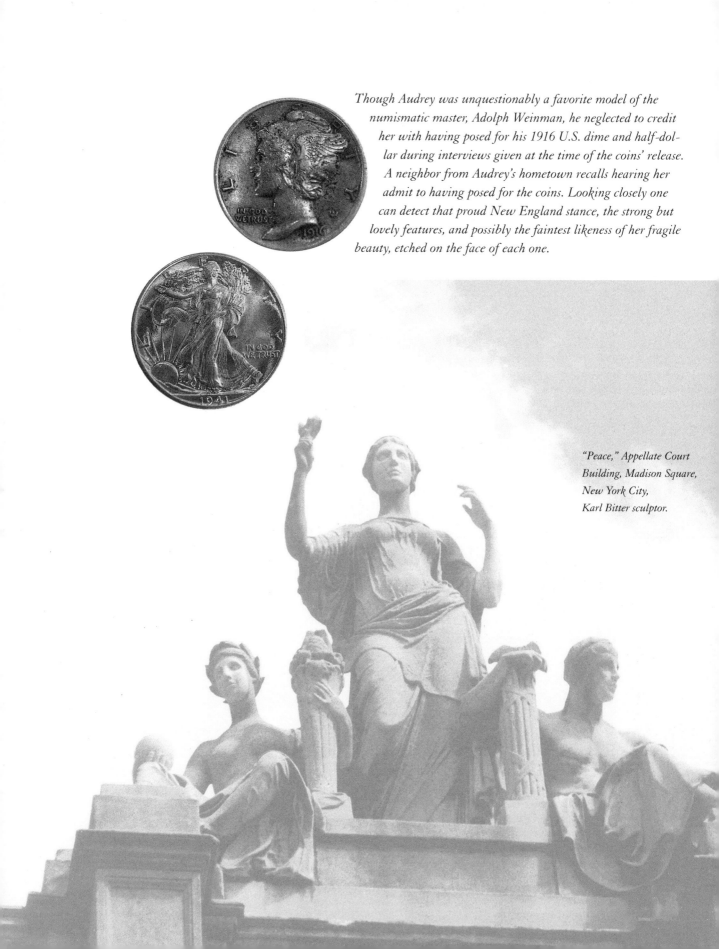

Though Audrey was unquestionably a favorite model of the numismatic master, Adolph Weinman, he neglected to credit her with having posed for his 1916 U.S. dime and half-dollar during interviews given at the time of the coins' release. A neighbor from Audrey's hometown recalls hearing her admit to having posed for the coins. Looking closely one can detect that proud New England stance, the strong but lovely features, and possibly the faintest likeness of her fragile beauty, etched on the face of each one.

"Peace," Appellate Court Building, Madison Square, New York City, Karl Bitter sculptor.

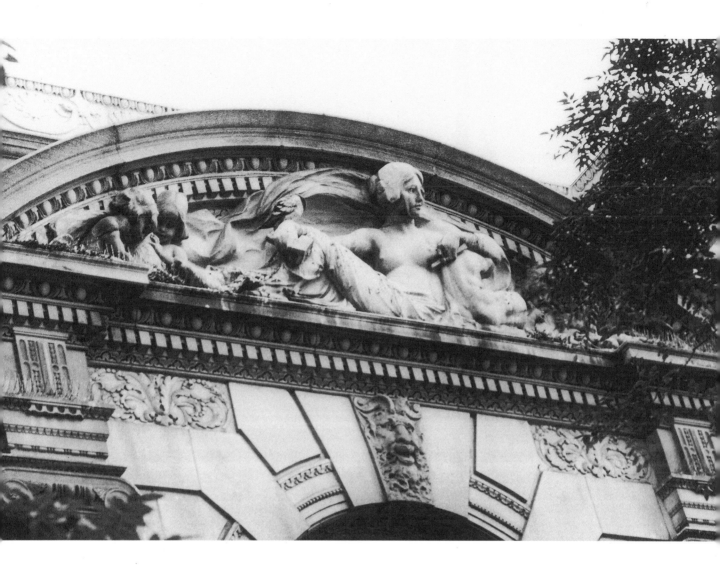

Pediments at the entrance to the Frick Collection, New York City. Sherry Fry sculptor.

"As the Greeks of old did, we try to idealize: it is the spirit of the idea that must be put into the work, and Audrey Munson is one of the rarely intelligent models who can catch an idea and enter into the spirit of the work."

—Sculptor Sherry Fry

A GENTEEL CAREER.

In the early 20th century, women seldom bore the weight of a daily job or career. Audrey, however, delighted at the possibilities, and took her role of model and muse with all seriousness which partially explains her popularity among the most highly regarded artists. She heeded their advice, and consequently, they entrusted to her body and spirit their most serious works. Although she capitalized on her natural gifts of charm, beauty and grace, Audrey relied even more upon her imagination to elevate herself above the notion of being a mere object for rent by the hour.

In frequent newspaper articles, Audrey revealed the challenges of the modeling profession. She insisted on careful discipline to be successful in the studios and to be taken seriously by society. She presented herself as an authority on the feminine arts by offering advice to girls considering a career in modeling. Since Audrey's success as a model relied on "deportment"—a woman's stance and carriage—she advised posture training in youth. Her suggestions included taking youngsters to museums to view statuary. Strongly opinionated, she gave specific advice in the *New York American* (1915) to parents of young girls considering a career in modeling:

"Children should be shown beautiful pictures and should be taken to see lovely statuary. If I had the task of training little girls to be graceful, I should have many mirrors in the house, and I should arrange to have her play and study and exercise between these mirrors. So after a child has had glimpses of herself standing, sitting, walking, and dancing correctly, the correct postures will become a habit she will have acquired that without which beauty is almost naught. It is better to keep before a child models of grace than to keep correcting her when she is awkward. This could induce painful self-consciousness, perhaps a shyness, that would cause lasting awkwardness. Set an example in graceful movement yourself!"

To the *Cleveland Plain Dealer* (1916) Audrey explained:

"You can't be both athletic and beautiful! Eschew all athletic exercises! Athletics over develop certain muscles, destroying the natural symmetry of the form. The swimmer or the dancer would be hopeless as a Grecian Goddess. Don't make up! Face rouge, lip rouge and powder are not allowed except for commercial advertising and costume posing. If one wishes to be successful, one must study art and try to understand it. Thus a model is able to put into pose the feeling an artist desires. In the studio there are thousands of wonderful things to be learned. You come into contact with cultured minds able and willing to impart the spirit of the lands of music, art and literature."

SOCIETY DISPLAYS BRILLIANT GOWNS AT FOREST HILLS TENNIS MATCHES

Well-known society women at Forest Hills yesterday. From left to right are: Miss Anne Markey, Mrs. William Earhart and Miss Louise Burrell.

SOCIETY journeyed to the tennis courts at Forest Hills yesterday and became unmistakable as the Eastern states were played. Those who sought the court because of their devotion to the racquet lingered to admire the kind of well known fashionable people who showed smart gowns and modes that were certainly new and fascinating to have dwelt about attending of the new crowd to high set sterous-colliers, but Mrs. William Earhart, who wore a stunning gown of black, had her new cloth hat by reason of the fluffy ostrich that was beneath it.

The spectators of this crowd, so full of men who seemed at ease socially and whose raiment would make up the crowd that was chosen as the outdoors feminine. The yesterday with an array of outlines the prettiest style in feminine. Miss Louise Burrell who certainly enjoyed the day cordially, as the last mile Markey, who

FOR THE STORY OF THE GREAT MATCH SEE SPORTING PAGES.

Society Still Doing Its Best for War Charities of Newport

By CHOLLY KNICKERBOCKER.

I CANNOT lay the great stress on the excellent work Newport has been doing done in connection with charitable entertainments for the aid of suffering humanity in Europe. A summer hits in behalf of alarming Belgium over the multi-...

Miss Bister Will Be a Bride To-day

PHOTO BY CAMPBELL STUDIO 586 FIFTH AVE.

F. B. Colver to Wed Miss Ross To-night

THE wedding of Miss Alice M. Ross, of Englewood, N. J., and Frederick Beasley Colver will take place this evening in the Englewood Presbyterian Church.

MISS WARFIELD TO WED.

MISS ROSS TO WED.

Making Bread by Thunder a Triumph of Science

By WOODS HUTCHINSON, A.M.M.D.

THE miracle of the loaves and fishes is being repeated to-day by science. Faced by the weaving off of our wheat field, and the wasting away of our nitrogen, she has called down the thunderbolt and harnessed the lightning to our bread wagon.

It is a striking illustration of the huge difficulty of weakening up the sleeping giant, nitrogen, tremendous as he is when aroused, that one of the only two available methods is nothing less fierce and dramatic than the thunderbolt of lightning flash.

Nature gave us the first hint in this direction, and it was easily discovered in the study of both electricity and chemistry that the clean, pungent, biting odor in the air directly after a flash of lightning was due to the formation of nitric acid fumes and ozone, literally squirted out of the air by the tremendous heat of the electric current.

CROPS PROTECTED.

For many years this was little more than one of the curiosities of science, but gradually as electricity became cheaper the possibility of producing one's own lightning flash for this special purpose became more and more feasible, until finally, with the harnessing of our mountain streams and other water power at greatness of electricity, it became a commercial possibility.

ORGANISMS AID GROWTH.

SUN MOTOR POWER.

Mrs. Belmont on Way to Exposition

Newport, Sept. 7.
MRS. OLIVER BELMONT started to-night for the San Francisco Exposition, accompanied by Miss De Barritt. Mrs. Belmont will attend the suffrage convention in San Francisco.

The Newport horse show officials, pleased with the success of the recent exhibition, have chosen August 31 and September 1 and 2 for their next year's show.

AUDREY MUNSON TELLS HOW WOMEN CAN WARD OFF THE SPECTACLE SPECTRE

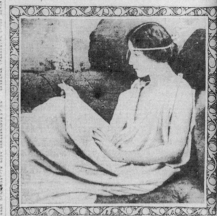

A pose of the famous model, Audrey Munson showing how women should protect their eyes while reading.

MISS AUDREY MUNSON, who today presents the second article to her series on health and beauty for this newspaper, is the most famous model in America known as the Panama Girl, because Madame du Fog and her figure of Venus de Milo, and represents the ideal proportions of Venus de Milo.

By AUDREY MUNSON.

NO woman can maintain her claim to beauty if her eyes show little red, threadlike lines of strain; nor if there are lines of weariness around them, nor shadows of illness or exhaustion beneath them.

Eyes should be clear and bright.

Miss Jean Webster Is Lawyer's Bride

MISS JEAN WEBSTER, young author of "Daddy Long Legs," who is so busy working on her new play, "Dear Enemy," she did not have time to arrange the details of her own wedding, was married yesterday to Glenn Ford McKinney, a lawyer, of No. 34 William street.

Society Notes

THE Philip A. S. Franklins are making a brief visit at the Plaza. They expect to return to their country place at Rockbridge, Va., in the latter part of the month.

Suit of Broadcloth with Muff Pockets

HEALTH & BEAUTY — SOCIETY & FASHIONS — WOMEN'S CLUBS

ONE VIEW OF CIRCUS MAKES ALL CHILDREN KIN

A CIRCUS is a circus through-out all the realm of child-hood. Wealth cannot destroy its grandeur, nor colossal red fes-toon mitigate its joys. The stu-pid ring has a real and legitimate fascination for every natural child, and all the gold spoons in the world cannot destroy it. The youngsters of the rich are not so delighted at the feats of the horse-

man and the brilliant humor of the clown as are those of humbler mien.

Behold these children who are supposed to be surrounded by every-thing in their home to make them happy.

The photograph was taken at Piping Rock on Saturday, where Squadron "A," the crack troop of the National Guard, gave the circus for charity.

Miss Harriet Pratt. Master Fred Pratt. Miss Eleanor Pratt. Miss Florence Pratt.

"Shalt Not Flirt," Mandate for Wedded, Says Miss Dix

Dalliance of Those Who Find Matrimony Dull Leads to Disaster.

By Dorothy Dix.

THIS is the eighth command-ment of matrimony:

Thou shalt not flirt with other women, or call thine orbs at the man with whom thou fanciful-eth, for jealousy is as cruel as the grave, and the short cut to Reno.

One of the favorite amusements of both men and women, who find matrimony dull and monotonous, is to engage in what they call harmless flirtation. Which is as if one exploited an innocuous stick of dynamite or a frolicsome viper.

Now, the married flirts are not necessarily conscienceless vil-lains. Neither are they always traitors, or even really untrue to the partners of their bosoms. They are merely bored. They are victims to the curse of domes-ticity, which robs married life of all its illusions, strips from it pink chiffons, and leaves it bare and bald and commonplace.

LOVES HIS WIFE, BUT.

In his heart, a man may still think his Matilda Jane a model of all the virtues, and the pattern of what a good wife and mother and housekeeper should be. If he had to marry, he would marry her over again.

BUT —

Well, there is no allure in mak-ing love to your own wife when she brings with bad her ear to your impassioned vows and on the other ear and a half cocked to hear the baby cry. There's no thrill in wooing her favorite flowers to a woman who would rather have the price to go on a new pair of shoes. There's no glamor of romance in having a lit-tle dinner somewhere with the lady who has the legal right to face you across the table three hundred and sixty-five mornings and evenings a year.

And the woman who is bored with the eternal roast beef and boiled potatoes of matrimony, and whose palate cries out for some-thing with a little more pep and ginger in it, is tempted along the primrose path of flirtation by pretty much the same impulses as her husband is. She, too, is a hungered for romance, and, more than that, she is beset by a dev-ilish fear that torments her and will not let her rest.

Her husband has quit making love to her. He has ceased pay-ing her compliments. He treats her with as little sense of her be-ing a woman, as if she were a fem-inine memory of the time of the Ptolemies. She raises a horrid suspicion in her breast. "Am I old and ugly already? Do I no longer attract men? Have I thrown away my last or lost it?" she questions of her mirror.

DISASTER THE END.

Whatever the reason of the flir-tations of married folks, however, there is but one end to them, and that is disaster. You cannot play with the fires of passion without getting burnt.

This is especially true of wom-en. A woman's flirtation may not be skin-deep in sentiment. It may have been inspired by the most fleeting impulse of vanity, just a whim to see if her eyes had lost the power of a few and her girlhood. She may have merely trifled and received a silly note or two or had a cup of harmless tea at a restaurant. Her soul and her state may be absolutely clean, and in reality she may still hold her husband as far above the man

she is flirting with as the stars are above the earth.

Nevertheless she is running the risk of wrecking her life and home. Thousands of women have been damned for just so little. She is taking the best of their feelings, and there will not be lacking those who will point out the stain and nail her husband's at-tention to it. And she can never, never, never explain. And no-body will ever, ever, ever believe the truth. Least of all will her husband believe it.

When a married woman flirts it generally ends in divorce for her. When a married man flirts it doesn't end so often in divorce, for necessity forces wives to forgive things in their husbands that hus-bands do not have or forgive in their wives; but it ends in broken hearts just the same.

There is no safe flirtation in which married people can indulge. All the ways of dalliance are closed to them, and they stray over the bars at their peril. Therefore, say as I said when the comes whispering in your ear, "Get thee behind me, Satan, for I partake no more of nonsense, except of the well-known domes-tic brand that is made at home."

Thou shalt not keep out of trouble and safe within the fold for this is the eighth command-ment of matrimony: THOU SHALT NOT FLIRT WITH OTHER WOMEN, OR ROLL THINE ORBS AT THE MAN WITH WHOM THOU FAN-TROTTETH, FOR JEALOUSY IS AS CRUEL AS THE GRAVE, AND THE SHORT CUT TO RENO.

The next article will be on the ninth commandment of matrimony: "Thou shalt covet no other place above thy home, neither thy hus-band's office, nor thy bridge table, nor any cause shall thou put before his home, nor neglect thy home for it."

Miss Bigelow to Wed H. C. Peff, Jr., Nov. 3

Newport, Nov. 12.
MISS MATILDA BIGELOW, of New York, and her fiance, Herbert C. Peff, Jr. of Toronto, have concluded a visit with Mrs. James F. Kay, at Newport, celebrating the approach-ing wedding which will take place on November 3 at the home of the bride's mother, Mrs. John Bigelow, New York. It will be one of the most conspicuous social events of the winter.

Mr. and Mrs. Morgan Belmont, who have entertained Miss Margaret Andrews, have been entertained by nearly everyone here. While here as his guest at Newport, while here, they are in Miss Francis low, with her lates two yacht here, will be shipped to their new home.

"NO BEAUTY WITHOUT GRACE," SAYS AUDREY MUNSON

Grace is Clearly Expressed in the Pose of the Beautiful Model, Audrey Munson.

By Audrey Munson

Let every movement be a picture. The woman of our country are careful of their complexions, they, as a rule, give moderate attention to their hair; they are proud of their face and keep them well shod, they are mindful of the daintiness and look inside; but they are care-less of posture.

Parisiennes admire our vivacity. They compliment us upon our in-dependent interiors. They assert that we have taste in dress, or if not taste, that we make up the lack in courage. But they almost never carry their admiration to the point of saying that we are grace-ful. For to very, very many in-stances we are sad.

"Try to stand like that," the gown in the figure said, "the down on his lips you have exceedingly that ounce of thyself broke its sinews." "You set as gracefully on the low canvas chair, if you will."

If I had the tact of training little girl to be graceful I should have many mirrors in the house. I should arrange to have her stand and study and explore before those mirrors.

"GRACE WILL BECOME A HABIT."

As after a show her self glimpses of herself standing, sitting, walk-ing, dancing correctly, the correct posture will become a habit. And she will have acquired that which is so beauty a woman can possess.

"It is folly to keep posting child models of grace that to di-rect her ways she is untaught. You would reflect mental and unconscious portraits a dignity would cause lasting awkwardness. Rather set an example in graceful movements yourself."

"SHOULD BEGIN AS CHILDREN."

Children should be shown beauti-ful gestures and should be taken in are hands earliest. They should

WHERE "ELAINE" MAY BE SEEN

MONDAY, TUESDAY AND WEDNESDAY.
MARCUS LOEW'S THEATRES.
New Rochelle—New Rochelle, N. Y.
OTHER MONDAY EXHIBITIONS.
Loew's Ave. 9—9th st.
Fox's Family—117 E. 125th st., N. Y.
Fox's Name—110th st. & B'way.
Herald Square—B'way & 35th st.
Circle—B'way & Columbus ave.
Gem—389 East 149th st.
Rainbow—1439 3d ave.
Park West—163 West 99th st.
New Third Ave.—1703 3d ave.
Classic—264 West 181st st.
Regent—28th st. & 3d ave., N. Y.
Orlory Lane—8th ave. & 40th st.
Schuyler—Ed st. & Broadway.
Playhouse—72d st. & 1st ave.
Crescent—Broadway & 135th st.
Kenney's—142d st. & 3d ave.
Manhattan—109th st. & Manhattan.
National—Houston & Chrystie sts.
Lincoln—Bloomfield, N. J.
Paradise—187th & Teller ave., N.Y.
Castle—62 Bleecker st., N. Y.
Bohemian—1556 1st ave., N. Y.
Malbin—389 Grand st., N. Y.
Windsor—412 Grand st., N. Y.
American—238 East 1d st., N. Y.
Empire—517 9th ave, N. Y.
Phoenix—350 East 41st st.
Royal—Willoughby st., Brooklyn.
Globe—306 1st st., Brooklyn.
New Ro—281 Graham ave, B'klyn.
Sumner—265 Sumner ave, B'klyn.
Plaza—101 Grand st., Brooklyn.
Lincoln—Bedford & Lincoln, B'klyn.
Prospect—267 Prospect Pk. W., B'k.
White House—Flushing ave, B'klyn.
Brooklyn House—Coney Island.
Clarendon—570 Myrtle ave, B'klyn.
Photoplay—88 21st st., Brooklyn.
Alhambra—214 5th ave., Brooklyn.
Crescent—214 5th ave., Brooklyn.
Miller—Sutter & Miller, Brooklyn.

Palace—465 Graham ave, B'klyn.
Manhattan—Crescent, L. I.
Garden—Richmond Hill, L. I.
Model—Yonkers, N. Y.
Hyperion—Corona, L. I.
Lyceum—College Point, L. I.
Castleton—Bay Shore, L. I.
Manor—Richmond Hill, N. Y.
Glen Cove—Glen Cove, L. I.
Forest Park—Woodhaven, L. I.
Casino—Riverhead, L. I.
Century—Mineola, L. I.
Bijou—Huntington, L. I.
Fox's Carlton—Newark, N. J.
Savoy—603 Bergen, Newark.
Savoy—West Orange, N. J.
Art—Livingston, N. J.
Playhouse—Arlington, N. J.
Savoy—605 Orange, Newark.
Garden—Elizabeth, N. J.
Gem—New Brunswick, N. J.
Empire—New Brunswick, N. J.
Broadway—Bayonne, N. J.
Lincoln—Bloomfield, N. J.
Pleasant Hour—Passaic, N. J.
Majestic—Red Bank, N. J.
Park—Newark, N. J.
Lyric—Atlantic, N. J.
Savoy—Madison, N. J.
Savoy—Asbury Park, N. J.
Bijou—Raritan, N. J.
Park—Branford, Conn.
Empress—Danbury, Conn.
Fox's Theatre—New Britain, Conn.
Alhambra—Stamford, Conn.
Lyceum—Stamford, Conn.
Palace—South Norwalk, Conn.
Beat—Millerton, N. Y.
Creston—Mount Vernon, N. Y.
New Colonial—Peekskill, N. Y.
New Casino—Ellenville, N. Y.
Hagen's Op. Ho—Susquehanna.
Liberty—3065 1st Ave., N. Y., C.
Odeon—145th St. & Ave. N.
Lindan Gardens—49 W.
N.Y.C.

Long-Waisted Frock For Slender Women

Blue, in contrasting shades, trimmed with silver thread embroidery, contributes charm to a youthful street frock.—From Bonwit, Teller & Co., Fifth avenue.

A CHARMING afternoon frock is made of dark blue Georgette crepe associated with rep silk in Belgian blue tone.

The model illustrated and of the long-waisted effects which are always becoming to women of slender lines. The tailored panel is elaborated with heavy silver thread embroidery, and these adorn-ments on the blue with such charm as the heavy tassel of silk threads.

It is very likely that fur popu-larity to cover the fashionable woman as covers the fashionable woman will return to wearing the blue or dark blue stitched in white thread.

Society Debutes Being Arranged

LIKE the primrose peeps during one month of May in "Merrie England," each April sees new buds added to the list of debutantes for the coming season. One reason why this Winter promises to be a brilliant one for this form of enter-tainment lies in the fact that many young ladies needing to remain veiled will have a coming-out party in this city as well as in their home town.

Since I last told you of the names announced for the coming season there have been added to the list the social number of miss as in the present time; there are hundreds and many who will be presented to the public.

Here are a few new names:
Miss Adele De Vean, Miss Edith Vogel, Miss Anderson St. Clair, Miss Marion U. Livingstone, Miss Ethel Field, Miss Beatrice Rep-ton, Miss Sydney Hoffman, Miss Dorothy Grau, Miss Marjorie Hoyt, Miss Mary Franklin, Miss Janet Cox, Miss Ethel Cook, Miss Ada Cox, Miss Edna D. Frank, Miss Alma de Guenzel, Miss Mary Kimball, Miss Cornelia Nabori, Miss Pauline Savers, Miss Elizabeth Holmes, Miss Mary Kemble, Miss Katharine Van Ransse-laer Tooms, Miss Frances Arley, Miss Katharine Carpenter, Miss Lincoln, Miss Sarah Leslie, Miss Helen Pierce and Miss Amelia Dal-ton.

Full enthusiastic view with con-certs can scrutinize what's being met by Thomas De Rancigny of Manor House, L. I., last week. With the ag-ing in a practice game with W. Hart-man of Oyster Bay next season.

Please, Malcolm Stevens and Howard Forrest to be Regelbrec poor rejoiced while making a turn in the tennis association carrying on the places with other visitors, prize winners.

REV. MABEL IRWIN TELLS HOW TO KEEP WIFE'S LOVE

Understanding at the Start Will Cause True Affection Throughout All Married Life.

By REV. MABEL IRWIN.

QUESTION—How shall a husband keep his wife's love?

JUST MARRIED.

ANSWER—This is a most difficult question. It is so novel that I will laugh much my youth away when I read it. I have seen a series of times "How shall I keep my husband's love" but never "How shall I keep my wife's?"

Men appear to take it for granted that a woman's heart once won her love is eternal and to the main the rest is right. "Love never dies, but it can be murdered" has in it a gist of truth—and love in woman's "hard to kill, you've waters on shelves unless trimmed wholly, unwater-like, the the unseen of love is easy to crush away.

THE BALANCE WHEEL.

Immigrant tell us that "The fe-male is the balance-wheel of the whole machinery of nature." He-cause of this, manifestness in love is best peculiar trait. The noble is variant and unstable. As the mother of all created things the female is more opportunistic than the male, and her sex-love is less likely to stray. It thus happens that wives take more reason to rear, or doubt the sex loyalty of their husbands than have the husbands their wives. But when the husbands know into but love behind me, then I will go with them through life.

I will tell you, however, the words I whispered into my ear at a honeymoon, just after the ceremony which pronounced him the husband of a sweet, flower-faced girl was over, and perhaps it will serve as a hint to you:

CAUTIONED IN TIME.

"If you want me to love you all the days of your life, never make her for a moment feel that you re-quire of her implied duties." He gave me a quick look of recogni-tion, then said: "I understand."

That was some two years ago; but recently I looked into the contest-ed, radiant face of the wife, hold-ing her beautiful baby boy to her breast, and I was satisfied that her love for her husband was more than the day when she was a bride.

Miss Hibben's Betrothal a Princeton Romance

SOCIETY heard with dignified pleasure the announcement of the engagement of Miss Elizabeth Hibben, the daughter of the pres-ident of Princeton University, but the students received the news with audible delight.

Miss Hibben's engagement is dis-tinctly a Princeton romance. She is to wed Robert Maxwell Scoon, one of the younger and more popu-lar professors.

Miss Elizabeth Hibben, Whose Engagement Has Brought Joy to Princeton.

In a later accounting of her career, published as a newspaper series, "Queen of the Artists' Studios," Audrey offers this advice:

"I learned for instance in the studio of one of the most gifted judges of female beauty in the world, why artists would not allow me to wear shoes with the high French heels; why I was not permitted, even, to have the dainty high-heeled "mules" I liked to wear about my bedroom at home and which are so popular with women today.

"I learned that the greatest of foes to feminine beauty are the kind of garters most women wear—the garter that holds up their stocking from the corset or from a belt at the waist; and why so few young women of today know what to do with their hands, how to carry them and how to use them in company because their clothes are in the way."

Of her professionalism and the sacrifices she made for her career she wrote:

"As a rule I am in the studio posing from 9 or half past in the morning until 5 or 6 at night. There is no time for late supper, and I shouldn't go to them if there was: a model who means business cannot go out and stay up all hours of night.

"Posing is very nerve trying: to stand in one position for half an hour, no matter how easy the position may be, is really a strain. To sit still in the same position when one is not thinking of it is simple, but when you come to concentrate your mind on the work and endeavor to hold expressions of face as well

as figure for thirty minutes without resting it is pretty trying. If a girl's nerves are not in excellent condition and her muscles strong and ready for such a test she makes but a wobbly sort of model and the artists cannot work.

"Another thing against the late hours is your appearance. Models who take their work seriously know that they must look well, they take care of their complexions and their tempers for it does not do to carry a nervous grouch to a studio with you.

"Girls who go to the studios to pose thinking it fun and a nice diversion will soon find their mistake. It is hard work and the girls who fail are generally those who are not sincere.

"How can a woman be a "bacchante" all night and become an angel at ten o'clock in the morning? Mr. French asked this question and the significance of it had much to do with my later career and taught me one of those lessons I needed to learn if I was to preserve the lines of my body and maintain the name I am so proud of."

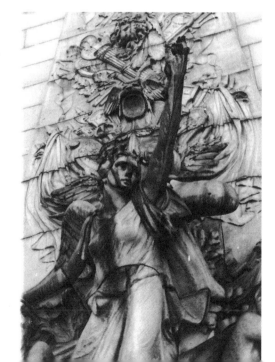

"Spirit of Commerce"
Manhattan Bridge,
New York City,
Charles Heber sculptor.

In 1913 *The Sun* published this story of Audrey's professionalism in an article entitled "Miss Manhattan."

"The man who made her famous as "Miss Manhattan" is Charles A. Heber, and his studio is located in the oldest corner of the city you could imagine. Twenty Fourth Street over near Eighth Avenue would be about the last place in the city to look for anything suggesting the Latin quarter: but there, sandwiched in among a lot of flat houses, is a door that looks as though it belonged to a trucking stable, and once it did. Inside one finds an unevenly paved court and at the back a large, roomy stable, the birthplace of Miss Manhattan.

"Yes, she is the real Miss Manhattan now," said Mr. Heber, "She has grit, determination and best of all, a sense of humor. One rainy day the fire went out and it couldn't be coaxed or coerced into burning and," Mr. Heber looked dismal, "I was in the midst of this work and Audrey put in an appearance at the appointed time. I told her it would be impossible to work because it was cold and the fire was out. She knew that I was very anxious to accomplish a certain point in the work and she looked both disappointed and scornful."

"What do you think she did? She just sent the studio boy out to get some braziers and said she guessed we could keep warm with those. He secured three from nearby and there we worked all the morning with the open coals glowing in their kettles. She

always has a way to get out of a difficulty, and that appealed to me as being a very clever stroke on her part."

However over-dramatized, Audrey recounted this story to emphasize her reputation as unflagging in physically demanding situations:

"One January day I was sent for by a distinguished artist who had an important painting to make for the Government of Mexico. On the canvas of his great easel he had already finished the background of a waterfall. And I noticed that he had his studio built up with a curious lot of planks and supports and a sort of big basin underneath. 'There—stand right there—turn a little this way—head forward, no not so much—that's it! Hold that pose. Now I'll turn the water on— I want to get the splashing over your form,' he shouted.

"Before I realized it a deluge of icy water overwhelmed me. With a scream I sprang out and indignantly refused to go back. Drawing a pistol from the desk the artist forced me to resume my pose under the plunging torrent of water and shouted that I was the first model who suited his needs and he would kill me if I dared move until he had finished.

"At the end of an hour he released me, and benumbed, I fainted on the studio floor. He apologized, begged forgiveness and paid for my attack of pneumonia which followed. And Carl Dorner's famous "Waterfall" hangs in the National Museum of the City of Mexico."

"Pomona" or "Abundance" on the Pulitzer Fountain in front of the Plaza Hotel, New York City. Karl Bitter sculptor.

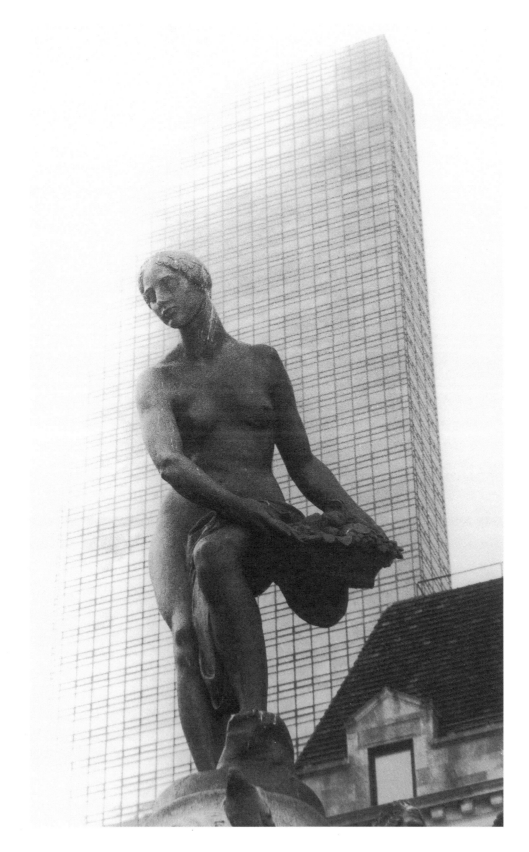

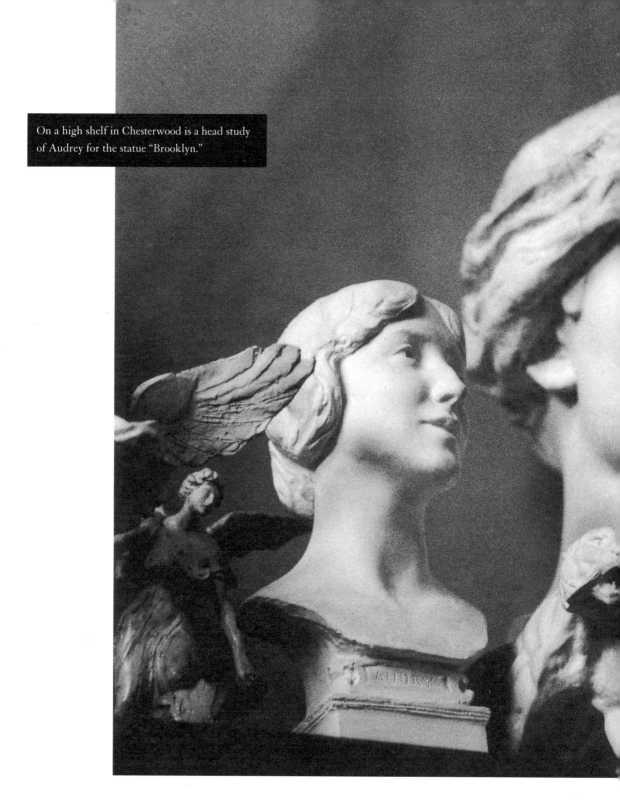

On a high shelf in Chesterwood is a head study
of Audrey for the statue "Brooklyn."

Her "particular style."

One of the many respected artists who recognized the muselike qualities in Audrey Munson was the quintessential American sculptor Daniel Chester French—born in Boston, educated in Europe—working in New York City in the early 20th century. He socialized with fellow artists, literary figures like Edith Wharton, and leading political figures including presidents. In midlife, he would inherit the mantle "Dean of American Sculpture" for his extraordinary achievements.

French's studio was located at one end of the already-famous downtown artists' area, MacDougal Alley, in lower Manhattan. Formerly a lane of carriage garages, these large airy structures with high ceilings and reasonable rents were perfect studio spaces for the painters and sculptors of the burgeoning Beaux Arts movement. Here they could create the enormous works required of their commissions. With his friend, architect Henry Bacon (also a collaborator on numerous projects including the Lincoln Memorial), French connected his studio from the alley to the large family home he owned on Tenth Street. (Gertrude Vanderbilt Whitney later purchased the MacDougal Alley buildings for the Whitney Museum.) By then, however, French had begun to spend more time in Stockbridge, Massachusetts at Chesterwood, his summer home, where he worked in a specially-designed studio space (today a part of the National Trust for Historic Preservation and open summers to the public). Some of

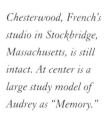

Chesterwood, French's studio in Stockbridge, Massachusetts, is still intact. At center is a large study model of Audrey as "Memory."

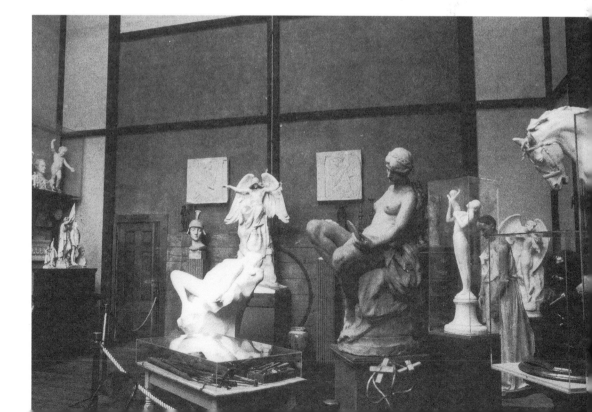

French's most beautiful and best known works are associated with the time he spent with Audrey. These include the exuberant "Spirit of Life," the figures on the U.S. Custom House, the relief sculpture "Evangeline" on the Longfellow Memorial in Cambridge, and Eve, the female figure on the "Genius of Creation" created for the 1915 Panama Pacific International Exposition, and of course, "Memory."

French said of working with Audrey, "I know of no other model with the particular style that Miss Munson possesses. There is a certain ethereal atmosphere about her that is rare. She has a decidedly expressive face, always changing. There is no monotony in her expression, and still the dominant feeling is that she is just such a type as many of the early painters would have selected for a Madonna. It is a great satisfaction to find so much grace and fineness of line combined."

Though no model is credited with the pose, French's Melvin Memorial of 1907 displays several distinctive characteristics of Audrey's figure. Her uniquely upswept hair, so similar to the hair of Weinman's "Descending Night" of 1906, gives every indication that she was the model. A later marble version of the memorial named "Victory Mourning," is housed in the Metropolitan Museum of Art.

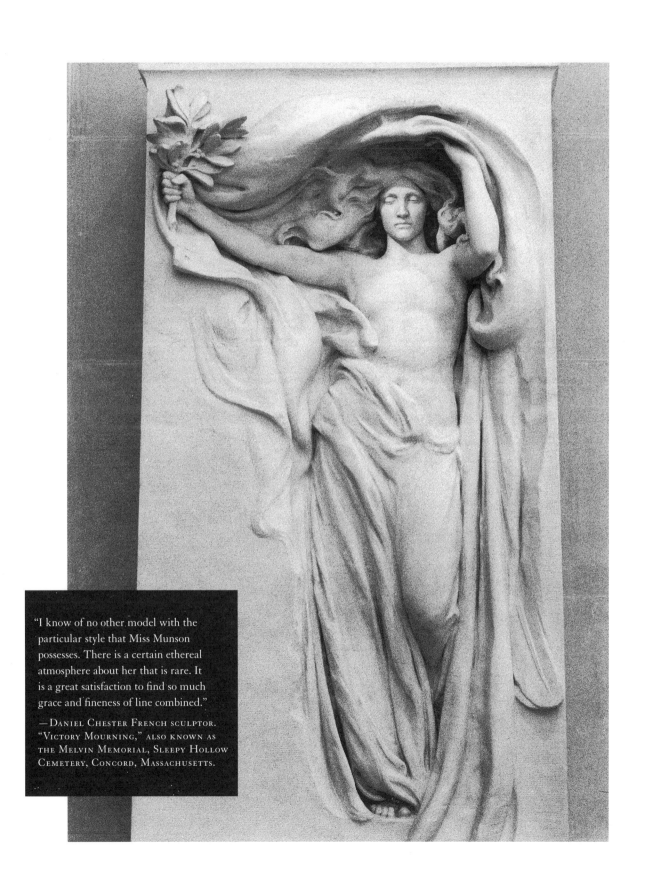

"I know of no other model with the particular style that Miss Munson possesses. There is a certain ethereal atmosphere about her that is rare. It is a great satisfaction to find so much grace and fineness of line combined."

—DANIEL CHESTER FRENCH SCULPTOR. "VICTORY MOURNING," ALSO KNOWN AS THE MELVIN MEMORIAL, SLEEPY HOLLOW CEMETERY, CONCORD, MASSACHUSETTS.

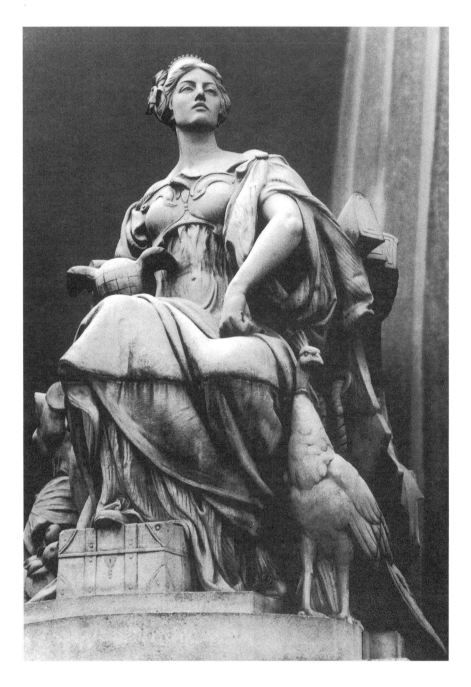

Brooklyn (r) and Manhattan (l), D.C. French sculptor,
now in front of the Brooklyn Museum of Art.

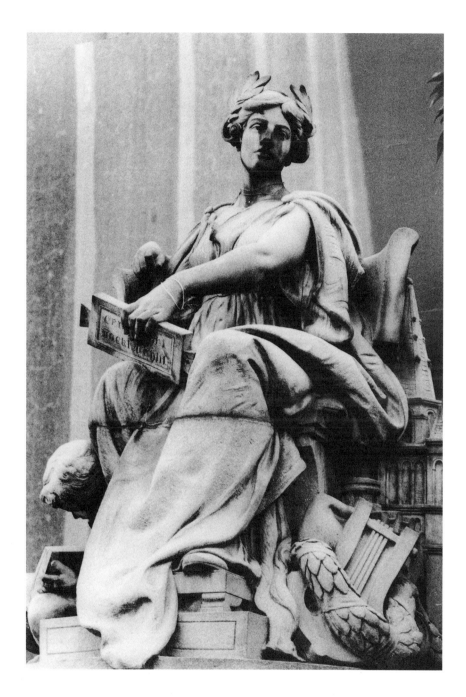

"Daniel Chester French, dean of American sculpture,
whose noble creations in stone, "Miss Manhattan" and "Miss Brooklyn"
on the [Manhattan] Bridge at the East River in Manhattan,
presents me with the view of the hundreds of thousands
who cross this great bridge every day of the year..."

— AUDREY MUNSON, THE SUN, 1913.

Head to toe Audrey's
various body parts were
widely praised; her dainty
feet, fluid arms and
expressive hands, her
graceful neck, perfectly
shaped legs, and, of
course, her lovely
dimpled derriere.

The elegant legs so casually crossed at the ankles, reflect one of Munson's peerless poses and most perfect body parts.

Audrey's legs and feet were well known among the artists of her day as being perfectly shaped. Her elegant legs casually crossed at the ankles was one of Munson's peerless poses. Head to toe Audrey's various body parts were widely praised; her dainty feet, fluid arms and expressive hands, her graceful neck, perfectly shaped legs, and, of course, her lovely dimpled derriere.

Still on view today in the Metropolitan Museum of Art in New York City, French's evocative and serenely beautiful work "Memory" has captured the attention of visitors for almost eight decades. The sculptor, in his diary, expressed these thoughts on "Memory" which was his most passionate work:

"I am afraid my 'Memory' shows too little of human sufferings, and I fear my inclination is to ignore too much the gloom and emphasize the beauty and joy of life—leaving out the snake which alas! was devised with Paradise. I haven't been able entirely to eliminate it from my everyday life, but why not at least forget it in the life that I live with my clay and marble folk? I like to think that perhaps for a minute or two, through my marble lady, you were led into the serpentless paradise of my dreams."

Nudity. A model's view.

Throughout time, from Praxytilies to Picasso, the question of "Nudity in Art" has been the source of scandal and discussion. In the early 20th century, the mere sight of a naked sculpture displayed in public was cause for some to riot in the streets. "Morality," or a lack there of, was the cry of this crowd. Audrey experienced her fair share of their wrath throughout her career as an artists' model and later as a star of the silent screen.

Though Audrey thought her nudity would be legitimized within the context of fine art, the self-appointed moralists had other views on the subject. To them, allegorical figures and sensual goddesses were no more than naked women displaying the evils of bare flesh. As her career progressed, Audrey's confidence in her own judgments increased. Nudity, in relation to her work, became a personal platform. It was in her view a "sacrifice" for the sake of art which required one to dwell nude in the realms of high ideals where clothing had no use or value. When posing uncovered Audrey was, in spirit, far beyond the everyday world of carnal activity. An interview in the *Columbia Dispatch* reveals her position:

"Audrey Munson has been candid in declaring she cannot see anything shocking in undress display. *"Why clothes anyhow?"* she asks. She asserts that except as protection when absolutely necessary, clothes come near to being the root of all evil. *"Clothes we began to wear,"* she adds, *"only when guile and evil thoughts entered our heads. Clothes ruined us. They do harm to our bodies and worse to our souls. We not only turn it into a passion for ornament, a lure for the senses, but girls even sell themselves and their souls for clothes. All girls cannot be perfect 36s with bodies of some mystic warmth and plastic marble effect, colored with rose and a dash of flame. Of course not. But clothing is more of a give away than the original itself. I am perfectly candid about these things. I detest false modesty. For my part I see nothing shocking in our unclothed bodies."*

looking over this masterful piece with horrified eyes.

She explains:

"Few controversies in art have been carried on so long or with so many incidents as has the storm of criticism and approval associated with this pagan girl in bronze. It was C. F. McKim, the noted architect who designed the Boston Public Library, who gave MacMonnies the commission to do a statue as a tribute...to the world of literature and art which centers around this seat of learning. MacMonnies wished to create not only a piece of exquisite art, something worthy of his skill, but something that would carry with it a bit of history, a suggestion of the past of which the library was to inform the world, and a message to those who came to see the marvel. In due time the statue arrived in Boston, hidden in its crate. The grave and dignified committee of the Library Board gathered in the rotunda to inspect it.

"When the nude, dancing figure was unveiled, there was a gasp, a shaking of heads and a hurried conference. Critics were called in, and there was much secret discussion. Some saw the spirit of MacMonnies' inspiration; others saw only NUDITY. The critics disagreed more violently than the members of the committee. It seemed inadvisable, however, to affront the donor, so the statue was set up in the court of the great building and the public was invited to a ceremonial public unveiling.

"Then the tempest in the teapot began to brew openly. It was not long before such a storm of criticism bore down upon the Library Board that the trustees decided their institution could not stand it longer. Critics, press and public were hopelessly divided. Some said the "Baccante" was the greatest achievement of art in a decade. Others declared it crude, horrible and an insult to public decency. Mr. McKim was notified that the Boston Library could no longer be a haven for the questionable statue.

"The name MacMonnies was sufficient to win for the marble lady an immediate home at the Metropolitan Museum of Art in New York. Once more boxed, she was admitted to this holiest of holies in the world of art, and was proudly displayed in a place of honor among the works of contemporary artists.

"Other critics, just as authoritative and responsible, jumped to the defense of the "Bacchante." The pose, they said, was such a difficult one to handle, and the sculptor had imparted to it a freedom and lightness with a perfect balance, that was little less than a marvel of technical skill; her smile, they said, was a symbol of the joy of living; the nudity, they said, was emblematic of fundamental beauty, and the sculptor, with exquisite art, had almost accomplished the utmost in imparting the sug-

gestion of dancing action to a nude figure with-
out accentuating the flesh appeal. And the baby
was winning, chubby and natural, looking up
as any child would at the gleaming grapes above
him. What, they asked in conclusion, could be
greater art, a greater masterpiece!

"The trustees of the Metropolitan were
not easily influenced by outside discussions,
but there was considerable uneasiness among
them. They were greatly relieved when Boston
relented and asked the return of "Bacchante,"
this time for its Museum of Fine Arts, where it
was included in the exhibits in the new wing.
But the Boston tempest was immediately
revived, and after a while the unclad lady
was again banished.

"Brooklyn, the home town of the great
sculptor, a city of far more churches than
Boston, now came to the front with a request
that it be given the honor of providing a
permanent and happy home for the controver-
sial work of its famous son. Accordingly the
much discussed marble was crated a fourth
time and then installed in the Museum of the
Brooklyn Art Institute, where it stands today,
a magnet that draws art students from all over
the country. The Metropolitan of New York
afterward regretted its decision to part with
the lady, and now has to content itself with
a bronze reproduction."

—Queen of the Artists' Studios, 1921

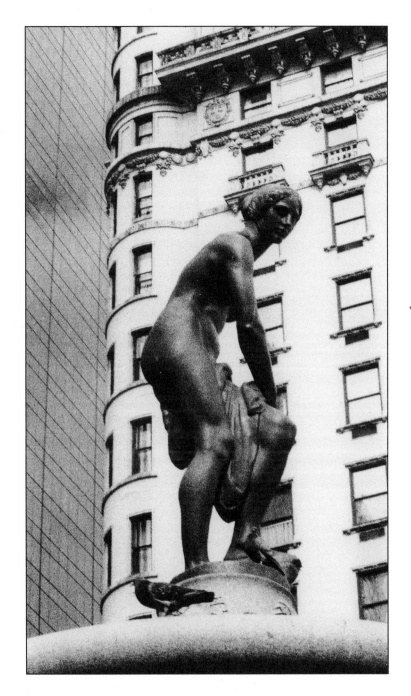

"Apparently a nude lady can stand in front of
the Plaza Hotel for years without anyone both-
ering about it until America's newest and most
inquisitive audience, the television fan, sees
her. While cameramen still were televising a
fashion show on Fifth Avenue the other day,
video peekers started calling in and asking
about the history of the beautiful statue of a
nude that distracted their attention from the
fashion models. After a frantic canvas of the
Plaza personnel, some bright soul remembered
that Clara Bell Walsh has been a resident of
the Plaza since 1907. Taking a bashful look at
the statue, the aristocratic Mrs. Walsh opined,
'it was a Pulitzer memorial, sculpted by Karl
Bitter and modeled by dancer Audrey
Munson.' The information was relayed to
the fans and it is to be presumed the lady
will stand undraped at her post in front of
the Plaza for another half century without
anyone bothering to ask who she is or how
she got there."

—N.Y. World Telegraph, 1957

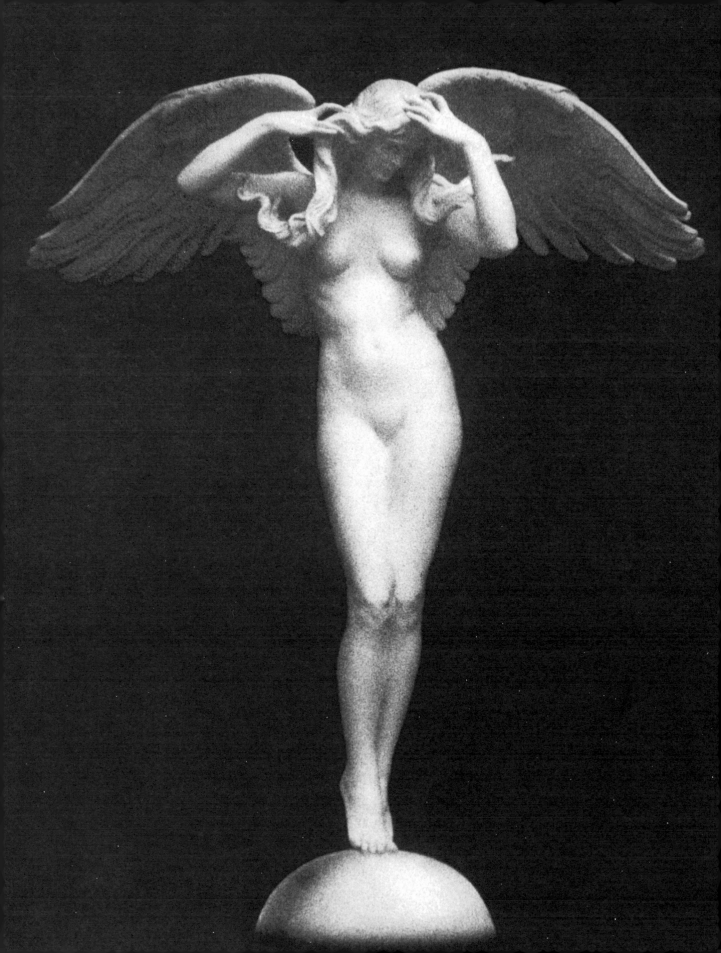

THE EXPOSITION GIRL

1913-1915

* *San Diego, San Francisco and New Orleans all made bids to become the site of the 1915 Panama Pacific International Exposition. • The U.S. Government not only selected its location but allocated several million dollars to its creation. • San Francisco won its quest to hold a fair in the city which had been ravaged by earthquake and fire. • The primary theme was to celebrate one of man's great achievements—the building of the Panama Canal—which, in its completion, caused thousands of men to lose their lives from malaria and exhaustion due to terrible working conditions. • The fair committee chose nationally famed sculptors and painters, craftsmen, architects and engineers to construct and decorate the fair, eventually installing nearly 1,500 works of original art throughout the grounds.* *

AUDREY, because of her gentle looks and all American features, was unanimously chosen by the top artists for the P.P.I.E. as the female model for the fair's many artistic representations including the commemorative coins and hundreds of murals and sculptures.

*"A young woman with pensive face, shaded by her hair and drooping
wings, sinks to rest. Her figure stands on a translucent shaft that is
a pillar of light in the evening…symbolizing the peace of night."*

—CHIEF EXPOSITION SCULPTOR A. STERLING CALDER
OF WEINMAN'S "DESCENDING NIGHT"

The Panama Pacific Exposition of 1915 was more than a fair, a celebration, or a place to have fun. It commemorated one of man's most courageous technological feats— the building of the Panama Canal. When completed, the astounding 50 mile long man-made waterway would forever reshape modern history, politics and economics.

San Francisco businessmen had been planning an exposition to mark the completion of the canal beginning in 1904. When the great earthquake and devastating fire of 1906 destroyed the city, the idea of the fair became a rallying point for a city eager to boost civic moral by a grand display, a resurrection visible to the whole world. After a stiff competition, and ultimate win over the cities of New Orleans and San Diego for the right to hold the fair in San Francisco, ground was finally broken in 1911 for the mile-long complex of "temporary" buildings which would be erected in the Marina District. Four years later, on February 20,

1915, the Panama Pacific International Exposition officially opened.

Previous international expositions held in such cities as Paris and Chicago were not only equaled in scope and concept but surpassed by the dazzling spectacles of culture, art, information and fun the P.P.I.E. offered its guests. From the day it was announced, San Francisco's fair was given unprecedented financial support and opportunities to display mankind's most current ingenious applications in the areas of electricity, manufacturing, food production and packaging, entertainment, gardening and the arts. Pavilions for these, and others representing states and countries, were constructed for the "Exposition on the Bay." Naturally, it featured a five-acre working model of the Panama Canal which demonstrated the operating of the locks though it was the extraordinary displays of arts and architecture which were perhaps its most stunning feature. A formidable and challenging

"On the coin is the central motif for which Miss Munson posed. It is the earth around which are placed two female figures suggesting the hemispheres. The cornucopias they hold are so arranged to typify abundance, the idea, of course, being that the canal brings the wealth of the world together. The seagull below is the bird of the canal zone. The reason I selected Miss Munson for this work, is because she is decidedly versatile. She is very beautiful in form and features, typically American in delicacy, and yet holds enough of a Latin suggestion in her features to make her just the ideal for the work."

—ROBERT AITKEN
SCULPTOR.

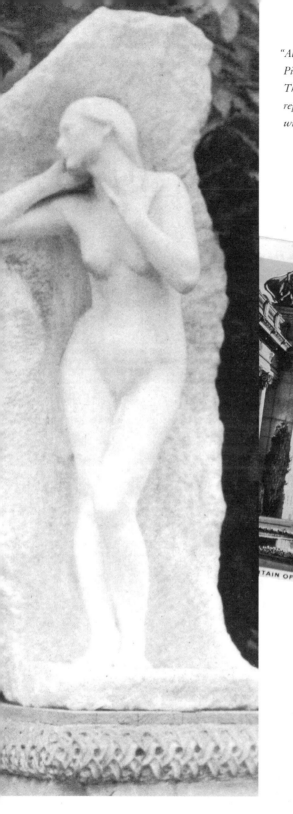

"Alone," P.P.I.E., Attilio Piccirilli sculptor. This figure is said to represent the anguish of widowhood.

Souvenir postcard from the P.P.I.E. shows Audrey Munson topping the "Fountain of Ceres" at the Court of Four Seasons, Evelyn Longman sculptor.

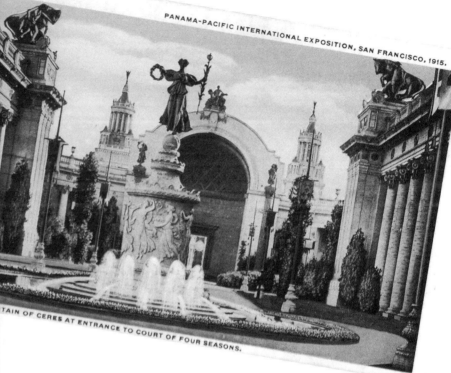

PANAMA-PACIFIC INTERNATIONAL EXPOSITION, SAN FRANCISCO, 1915.

FOUNTAIN OF CERES AT ENTRANCE TO COURT OF FOUR SEASONS.

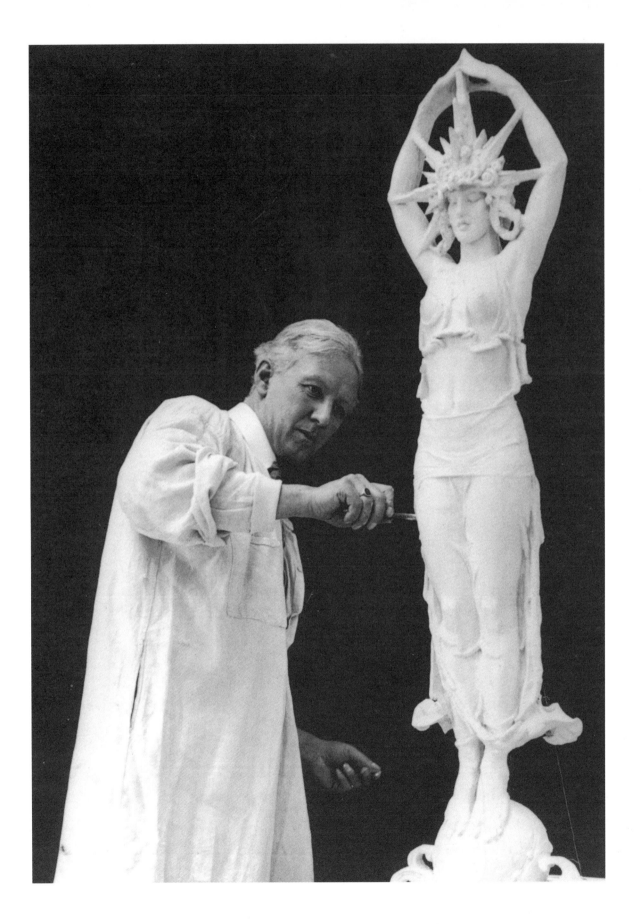

design opportunity, the fair's many buildings called for the country's top architects, engineers and designers. Also summoned to decorate the grounds were the country's most famous artists.

Possibly no other man-made construction for entertainment has ever truly equaled this amazing world exposition. For nine glorious months, the P.P.I.E. played host to over 18 million visitors who also discovered, just beyond the fairgrounds, the beautifully rebuilt city of San Francisco, then called the "Paris of the Pacific."

One aspect of the P.P.I.E. that set it apart from previous expositions was its stunning abundance of fine and majestic art. On columns, atop arches, in fountains, on pedestals and tucked into niches, as free-standing groups, on pediments, spandrels and friezes, were fifteen hundred works of sculpture, most commissioned specifically for the exposition. Chief of Sculpture, A. Sterling Calder (father of modern mobile sculptor Alexander Calder), and his hand-picked group of New York sculptors were given the prestigious assignment of providing the majority of the works that would decorate the grounds and buildings. Some of the works were created in the studios of the artists and shipped to San Francisco, though many were delivered in the form of small-scale maquettes. Right on the grounds of the P.P.I.E., artisans from Italy and France transformed the small clay maquettes into larger-than-life forms cut from travertine or molded in staff and

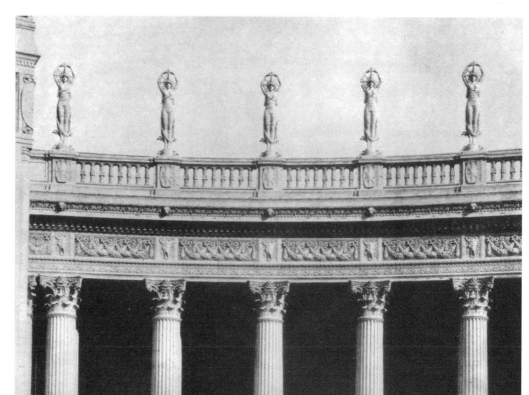

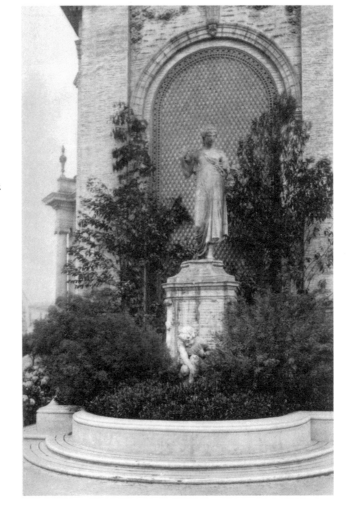

"The Muse and Pan," P.P.I.E., Sherry Fry sculptor.

In all, Munson posed for more than three-quarters of the female figures seen by the millions of visitors to the fair. In 1915 the New York American named Audrey "Miss Panama" and said, "Miss Panama is about five feet eight. She has black hair that is always waved simply from a center parting. She has wonderful gray eyes and her lashes are long and black."

plaster and then painted to exactly replicate materials such as stone and bronze.

As a group, Calder's artists in New York selected their male and female models for consistency. Why Audrey was chosen for the main female figures was obvious— besides her very American looks, she had already spent nearly a decade posing for many of their most important works. For several months during the creation of the works for the P.P.I.E., Munson moved from one studio to the next, interpreting artists' concepts with her inspired allegorical poses. We see the muse Munson once again taking such evocative forms as Loneliness, Consecration, Progress, the Seasons, the

THE EXPOSITION STATUARY
AND THE GIRL
WHO POSED
FOR IT

By GILBERD K. HARRISON.

WHAT constitutes the perfect head or the perfect form?

Ask one artist and he will tell you—he knows. Request the identical information from another and he draws out his latest sketch of all that is fair and vivacious within 'the marriageable zone of 19 to 22. Still another marvels over the exquisite beauty of his favorite model—and so on.

While America's foremost artists may be at variance with one another as to types,

Miss Audrey Munson in her favorite pose

As the 1915 "Flower"

One of the... in Court of Four Seasons

"Genius of Creation," in Court of the Universe

Go to the studios of the ... Piccirilli brothers in the Bronx, New York. You will find she posed for the figure in the decorations of the new Wisconsin State building, for the Maine monument, for the Firemen's monument, and for the new Pulitzer memorial. Go up on the Great Lakes and you will find her in the decorations of the new lake steamers made by William de Leftwich Dodge, who also used her as a subject for his great murals at the exposition.

Run back to New York, dine at the

"Descending Night" Crowning Figure on Fountain of Setting Sun Court of the Universe

As "The Exposition Girl"

there has been a singular unanimity of opinion as to the charm and grace about the face and figure of the little New York girl, Audrey Munson, who posed for the bulk of all the sculpture and many of the mural paintings of the Panama-Pacific Exposition.

How many American girls would like to see themselves atop the New City Hall, on San Francisco's monuments, in the illustrations of the most widely read weeklies, on the front pages of magazines, and in a thousand-and-one other places? What a sensation to behold oneself represented on the foremost works of sculpture at the exposition, where probably more than 20,-000,000 people will inspect the sculpture and paintings strewn in the art of the 625 acres!

WONDER IN ART WORLD.

But to Audrey Munson this is not a new sensation. Audrey is really a wonder in the art world. You would ne'er pick her out as a striking beauty; yet, if you looked twice, you would admit that she was uncommonly pretty and distinguished. America's greatest sculptors are ready to admit that she is the most perfectly formed woman who ever posed in an American studio.

Astor Hotel. She is there. On Fifth avenue you find her at the silversmith's, sitting dejectedly on a horse as Lady Godiva in a beautiful work by Scarpetti. In Washington you find her on the fountain of "Evangeline." On the exposition memorial coin, to be minted by the Government as souvenirs, you find her figure fully portrayed.

You open the weekly magazines and if you escape her on the colored page you find her in the drawings of Fisher, Gunn, Gibson, Wenzel and Hutt; and if, perhaps, you are invited to the new mansion of Henry Clay Frick in New York you see her there in the figure work of Sherry E. Frye.

Audrey, unlike the glamour and atmosphere customarily attached to a model, is a sweet, unaffected girl, residing with her mother in an unpretentious apartment in Upper Manhattan. She can make a pot of tea or toast bread over an open fire without the least show of importance.

"You see," said Audrey Munson, as she toasted her toes by the fire, "if an artist's model wants to keep the place she has won she must be businesslike.

"Study? Yes, indeed, I do. Every model who is a real success must study the work of the persons she is with. Many think that posing is simply taking a certain prescribed position and holding it for a stated length of time, and that, outside of the physical strain, it is easy. Try it and see. One must not only study the person for whom she works, but she must study his work and the character of the pose he would like.

"Every girl that wants a good figure when she grows up must lead a regular life, eat the right things, get good sleep, exercise, and, if possible, have regular massage. This my mother has done for me all my life. I have found that the artists say that their best models have always led simple lives—and abandoned corsets."

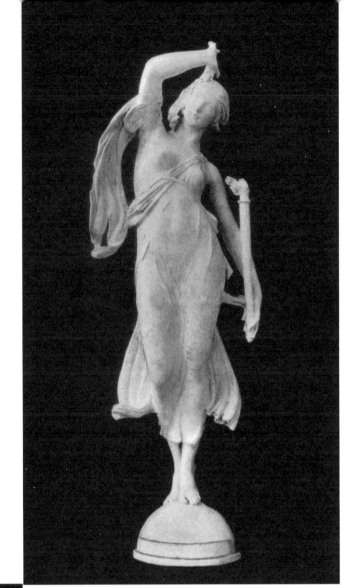

"Torch Bearer" by Sherry Fry.

> *"This young woman ought to be ashamed of herself. Maybe she has perfection, as the sculptors call it, of features and figure. That doesn't give her license to parade her charms to the general public."*
>
> —Elizabeth Gannis, founder and president of the National Christian League for the Promotion of Purity to the San Francisco Chronicle, 1915.

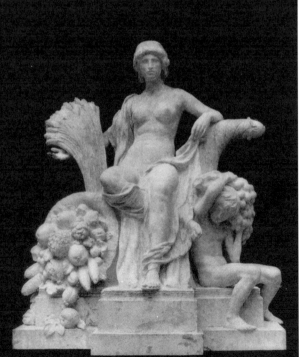

"The Harvest" by Albert Jeagers.

> *"It's the foolish notion of the artist that he must make a naked creature to symbolize everything in the world."*
>
> —Elizabeth Gannis, founder and president of the National Christian League for the Promotion of Purity to the San Francisco Chronicle, 1915.

From the San Francisco Chronicle, 1915.

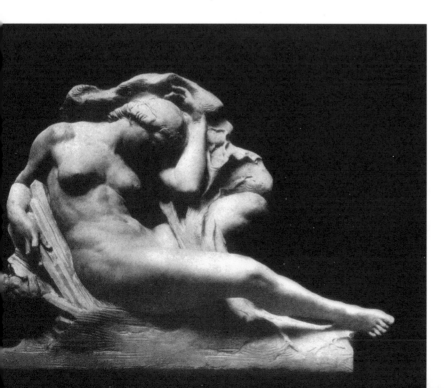

"Earth," Court of Universe, P.P.I.E. Robert Aitken sculptor.

Elements, various aspects of Music and Culture, Grecian goddesses and many others. In all, Munson posed for more than three-quarters of the female figures seen by the millions of visitors to the fair.

Though the modern era was being praised through the mile-long display of technological exhibitions, the nude statuary decorating the Exposition grounds caused an uproar with the ever-present moral minded critics. The *San Francisco Chronicle* covered the debate:

"San Francisco, with her Barbary Coast, is wicked enough", says Elizabeth B. Gannis, founder and president (re-elected twenty-nine times) of the National Christian League for the Promotion of Purity, "without strewing promiscuously through the exposition grounds' sculpted groups which bear the same lack of wearing apparel that made Lady Godiva quite impossible."

"Goodness knows, conditions must be bad enough when the chairman of the World's Purity Federation, after examining the exposition city, handed in his resignation. He exclaimed, "The nude statuary and paintings appealed to the senses at every turn, and insulted decency on every hand!"

"See this!" exclaims Gannis with righteous ire. "This young woman [Munson] ought to be ashamed of herself. Maybe she has perfection, as the sculptors call it, of features and figure. That doesn't give her license to parade her charms to the general public. It's the foolish notion of the artist that he must make a naked creature to symbolize everything in the world."

Allen George Newman, who executed several of the monuments for the exposition, answered and defended the artists' works by offering this thought: "The sculptor's natural way of expressing himself is to mold into form his conceptions. From the earliest ages beauty and truth have been expressed in the figure of woman. To the sculptor no other subject on earth presents what is beautiful and what is truth in so delicate and perfect a way. Criticisms of statuary modeled from the human form, and typifying what is beautiful in life, are indeed criticisms of what is beautiful and what is the truth."

"Eve" is the creation of sculptor Daniel Chester French, who conceived this, one of his most charming and delicate females, as earth's first woman to flank the main figure on the "Genius of Creation" grouping (his contribution to the Panama Pacific International Exposition of 1915).

Today, Eve stands in the sculptor's studio, sealed in a transparent box, protected from the changing seasonal temperatures of Chesterwood. If exposed to the air and elements, this decades old figure would soon crumble into no more than chunks of plaster. The sculptural figure study, formed as Audrey stood nude on a pedestal in front of the artist, is reminiscent of a very young Munson, and is as much a tribute to her convictions and her career as it is to French's appreciation of her gifts as a model.

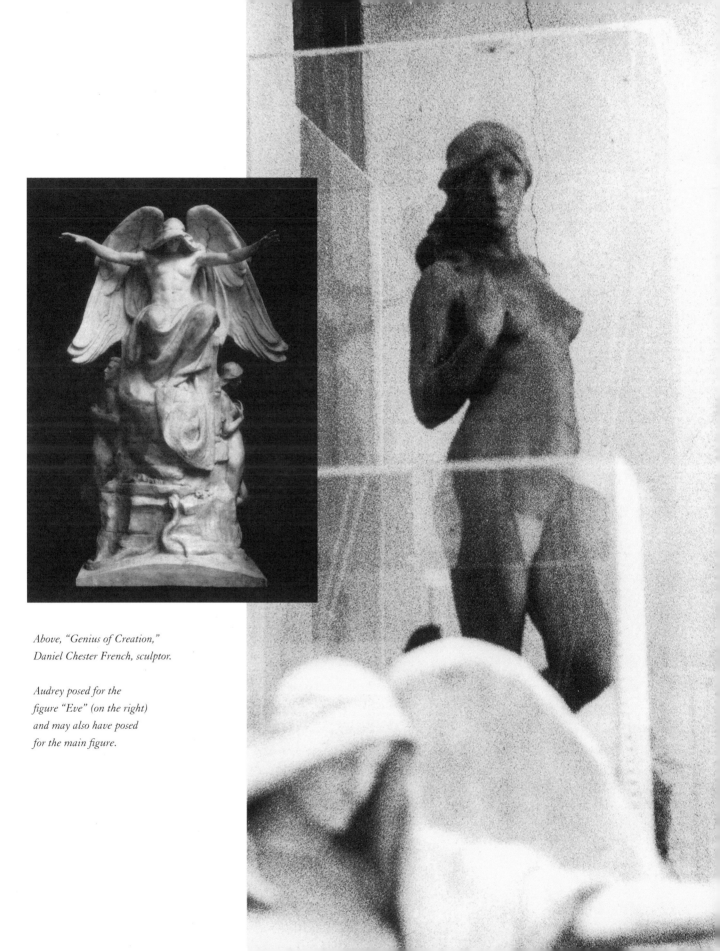

Above, "Genius of Creation,"
Daniel Chester French, sculptor.

Audrey posed for the
figure "Eve" (on the right)
and may also have posed
for the main figure.

AUDREY'S ACCLAIM.

"One of the great charms about Audrey Munson, outside of the fact that she is good to look at is that she is absolutely unspoiled."

—GERTRUDE
VANDERBILT
WHITNEY, SCULPTOR
OF THE "FOUNTAIN
OF EL DORADO,"
P.P.I.E. (LEFT)

Poses by the famous model ran through the Exposition like a theme. How had Munson worked her charms on the great American artists of her time? How did she gain such prominence as an artists' model and muse? Attesting to her versatility, Daniel Chester French was quoted in the New York *Herald* (1915), "It is interesting to note the great diversity in the work for which Munson posed and that she should have been chosen for subjects reaching from the wonderfully powerful, rugged sculptures of a man like Robert Aitken to the beautifully delicate figures of [my] "Genius of Creation." The artists agreed she had earned the titles, "Miss Panama" and "Exposition Girl." The *San Francisco Chronicle* reported on her success:

"There has been a singular unanimity of opinion as to the charm and grace about the face and figure of the little New York girl, Audrey Munson, who posed for the bulk of all the sculpture and many of the mural paintings of the Panama Pacific Exposition. America's greatest sculptors are ready to admit that she is the most perfectly formed woman who ever posed in an American studio.

"Audrey, unlike the glamour and atmosphere customarily attached to a model, is a sweet unaffected girl, residing with her mother in an unpretentious apartment in Upper Manhattan. She can make a pot of

"Fountain of Spring," Court of Four Seasons, Furio Piccirilli sculptor.

tea over an open fire without the least show of importance. *"You see,"* as she toasted her toes by the fire, *"if an artist's model wants to keep the place she has won, she must be businesslike. And study? Yes, indeed I do. Every model who is a real success must study the work of the persons she is with. Many think that posing is simply taking a certain prescribed position and holding it for a stated length of time, and that, outside of the physical strain, it is easy. Try it and see. One must not only study the person for whom one works, but she must know his work and the character of those he would like. I have found the artists say that their best models have always lead simple lives and abandoned the corset."*

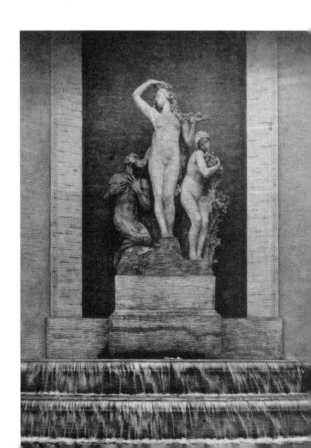

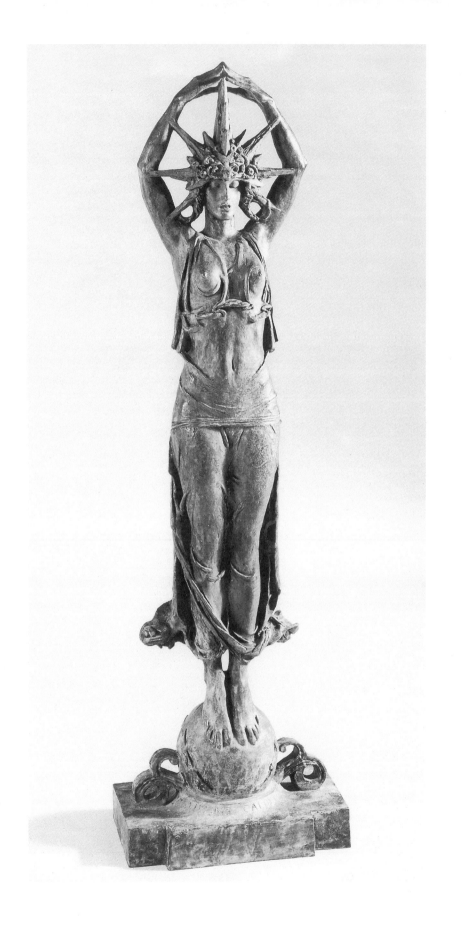

"Star Maiden,"
A. Sterling Calder sculptor.

"Priestess of Culture," Herbert Adams
sculptor, stands today in San
Francisco's Exploratorium, the
original site of the P.P.I.E. Palace
of Fine Arts

"Rain," Court of Four Seasons,
Albert Jaegers sculptor.

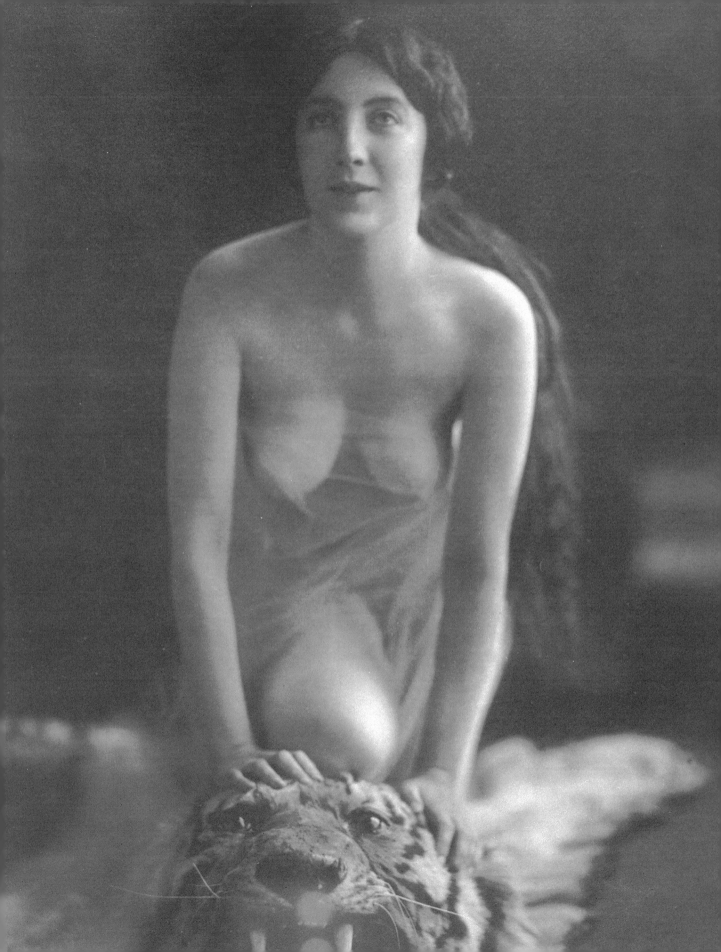

VENUS OF THE SILENT SCREEN

1915-1920

American soldiers joined the war effort in Europe while those at home sang, "Pack Up Your Troubles in Your Old Kit Bag," "Over There," and "For Me and My Gal." • *James Joyce's* Ulysses *was published in America.* • *People flocked to see the epic new film "Birth of a Nation."* • *The Modern movement in art challenged visual perception and raised the question "what is art?"* • *The* Saturday Evening Post *ran its first cover by Norman Rockwell.* • *Irving Berlin's hit musical, "Stop Look and Listen" featured a striptease behind a backlit screen.* • *The Coca Cola Co. sold its first fizzy brown drink in a curvy glass bottle.* • *Buffalo Bill died at 70, Mata Hari was executed for espionage, Czar Nicholas and family were brutally murdered in Russia.* • *Women got the vote, and 20 million worldwide were killed by a flu epidemic.*

AUDREY parlayed her fame into a controversial
film career based on the artistry—and nudity—
of her modeling

"None but prudes could find anything suggestive in the picture
which is one of the most artistic screen productions I have ever seen.
Miss Munson's work in classic poses which are a part of the play
alone would make the production worthwhile."

—SCULPTOR A.A. WEINMAN QUOTED IN *Reel Life* MAGAZINE, 1916.

Silent films—a world of hard working actors, short-term productions, travel, glamorous publicity stunts, and, of course, fantasy scenarios. This type of work offered the perfect transition for Audrey, a girl in her mid-twenties and already well known for her exceptional figure and muselike qualities.

By 1915, with Munson's name and nude poses gaining wider recognition, national magazine covers such as *Sunset*, frequently carried her image, the media declared her a modern Venus. She was widely visible not only throughout the streets and squares of New York City, but at the San Francisco Panama Pacific International Exposition which attracted 18 million visitors. In both cities she was recognized as the figure and inspiration of scores of sculptural decorations, murals, paintings, coins and medallions. At the height of her career, film-going audiences throughout the U.S. and Europe were also introduced to Munson—a woman whose shameless, though artistically inspired, nudity received as much praise from art critics and followers, as disgust from censors. Munson starred in three films during 1915 and 1917, and in 1921 was involved in one more production. All four films were well attended by millions of moviegoers.

Her first film, made in New York City in 1915, was a direct reflection of her modeling career. Although Munson was peerless when posing on a pedestal, as an actress she faltered. By the time her second film went into production, a stand-in actress, Jane Thomas, who looked amazingly like Munson, was brought in to perform the more demanding parts while Munson made the artistic nude poses. Jane Thomas would continue to perform with (and as) Munson in two more films that carried Audrey's name in the starring role.

Eventually, in her fourth and final film, Audrey would be the one to direct her own career, creating the scenario complete with high morality, nude poses, and an ending that made her character one who sacrificed for others.

Sunset *magazine ran this cover of Audrey as "Descending Night" in their October, 1915 issue to coincide with the P.P.I.E.*

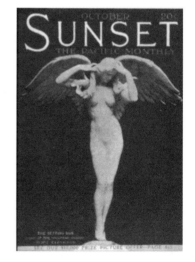

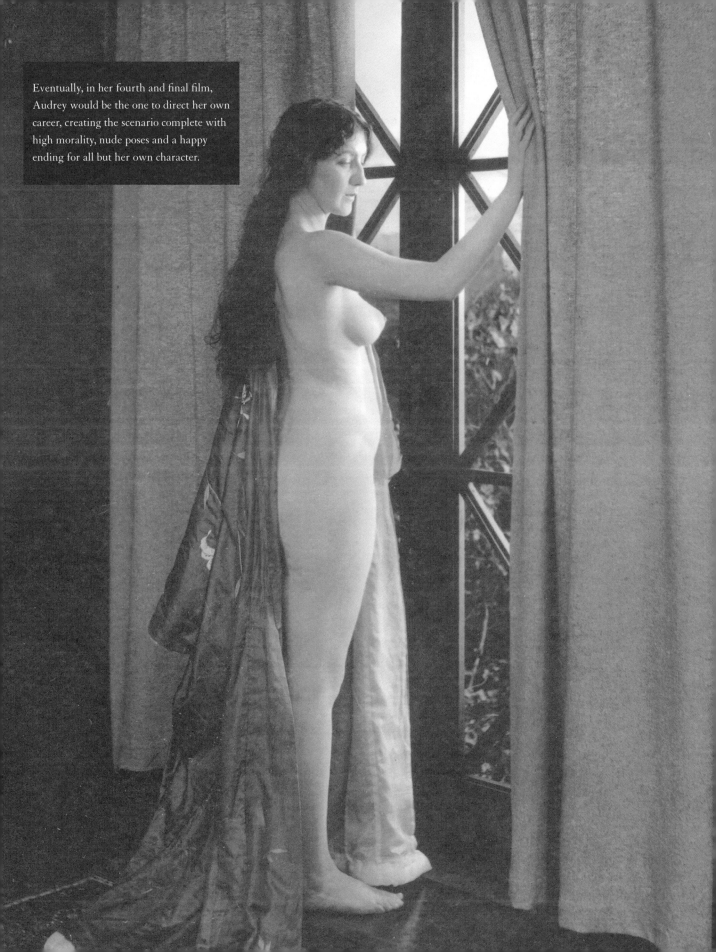

Eventually, in her fourth and final film, Audrey would be the one to direct her own career, creating the scenario complete with high morality, nude poses and a happy ending for all but her own character.

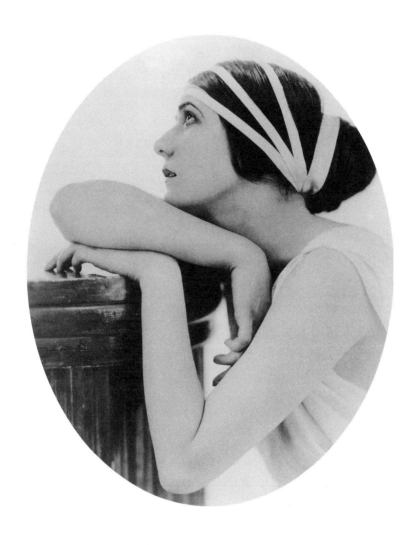

"I wouldn't think she'd want to do it.
I can't even think of her doing it....she used to be
such a nice quiet mannered little blue-eyed thing,
just the opposite from what you'd expect to see in an actress.
I don't take any interest in what she's doing now.
I'd rather she wouldn't, but it's her affair and it brings her
in lots of money, and she spends it—just like water..."

— EDGAR MUNSON, SYRACUSE HERALD, 1916.

"Inspiration."

The film in which she made her debut was insightfully created by one of the era's most prolific producers, Edwin Thanhouser, of Mutual Masterpiece Films in New Rochelle, New York. "Inspiration" partially mirrored Audrey's real-life career. Its plot was loosely based on the popular "classic-made-modern" play "Pygmalion," which included a romance for the film's stars which ended happily in marriage. However, in Thanhouser's version of the tale, cleverly woven throughout its five artistically-acted reels, was Audrey in the sculptors' studios in scenes that depicted the creation of her most famous works. There, for the motion picture camera, she took her famous poses once again, this time for the world to see.

Thanhouser proved to be not only insightful but experimental—he filmed the actual casting of a full-body plaster mold. The nude model, Audrey, was covered head to toe in wet plaster. After it dried, the plaster was painstakingly chipped away then reconstructed for later use—a common procedure for works of art incorporating groupings of life-sized figures. Thanhouser considered this display nothing less than educational, however, the nudity overshadowed his intentions and ultimately played the larger role. Many theaters stopped the showing before "Inspiration" could be seen by the public. Its supposed moral depravity touched off backlashes on many a Main Street across America. Moviegoers who refused to be deprived of seeing this unique film had to travel to larger cities to see it. "Inspiration," considered one of the first "nude" films ever made, was also one of the highest grossing films of its day, bringing in millions for its producer. Munson's $500 a week salary was minuscule by comparison to the enormous sums made by the producer. This situation, which she considered unfair, would haunt her for years to come.

The critics were at odds regarding the film's artistic value. In dozens of reviews those who saw only nudity in "Inspiration" couldn't be convinced of the film's artistic qualities; those of a more sophisticated point of view would revere every frame.

The *New Rochelle Evening Standard* reported, "The picture 'Inspiration' was to be shown yesterday at the North Avenue Theater. Before the doors were opened, a committee of clergymen and others asked Charles Jahn, manager of the theater, if they might have a private view of the picture before the regular performance, to which Mr. Jahn assented. What happened inside the theater is not known, but the committee

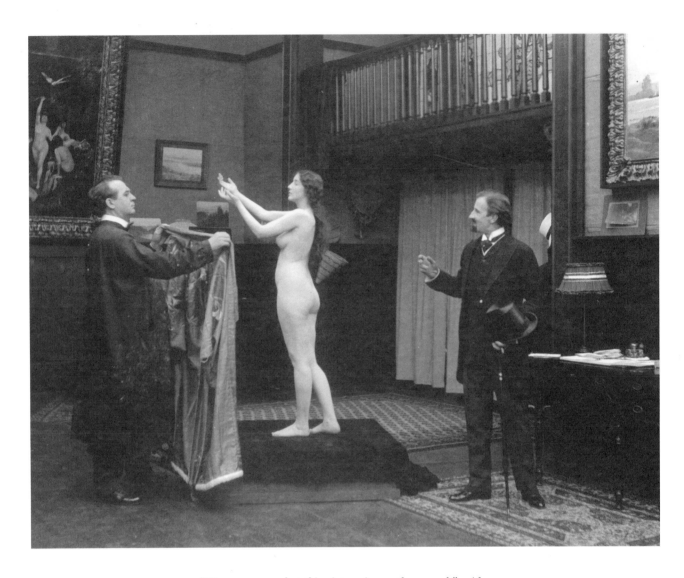

*"We cannot say that this picture is exactly amoral," said a
minister who acted as a spokesmen for the group of censors.
Yet he was of the opinion with his associate censors of critics
that the youth of the burg should not be suffered to gaze
upon the film portraying the shapely Audrey in the artist's
studio posing there so innocent like to inspire Mr. Artist."*
—THE NEW ROCHELLE EVENING STANDARD, 1916.

left by the side exit and Mr. Jahn appeared in front of the theater and announced that "Inspiration" would not be shown. Great was the disappointment among those awaiting admittance. There was much criticism and many complaints as well as uncomplimentary remarks."

"'Inspiration,' was one of the biggest days we have had since opening under present management," reported E.H. Hulsey, proprietor of the Old Mill Theater in Dallas to *Reel Life* magazine. "The picture has unusual value, and is a real money-getter... and absolutely free from any suggestion of vulgarity or indecency and as a consequence pleases the patrons."

An Oklahoma City publication reported, "...a woman's organization has added to the drawing power of 'Inspiration' by resolving against it...the picture proceeded, meanwhile ...to do a record business. There was no question but that Miss Audrey Munson appears entirely without the aid of a wardrobe, but no critic has dared to reflect on himself by charging that the picture was in the least suggestive. As a film seer we should promise "Inspiration" a long, eventful, prosperous life."

As the controversy played itself out in public, journalists saw the film as fair game for criticism and for praise. Sadly, this silent motion picture was not preserved and, along with the other three films in which Munson performed, is believed to no longer exist.

"Purity."

Audrey's second film venture, made in 1916, was called "Purity" and was one of the most elaborate and expensive film productions of its time. In the first frames of the film, a lone figure, Munson, stands before the camera. She utters the words of the Apostle Paul, "Unto the pure all things are pure," attempting to establish the story as one of morality and truth, seeking recognition of her own chastity in playing the dual roles of Purity and Virtue...mostly in the nude. *Reel Life* magazine described the scenario:

"The production which marks a new era in the presentation of artistic film spectacles, was produced at a stupendous cost in the studios of the American Film Company, at Santa Barbara, Calif.

"Several hundred players figured in the filming of the big feature. Miss Munson... who has posed for many of the greatest modern works of sculpture, recreates at a large garden fete, with hundreds of men and women gathered....A special stage was erected at one end of the lawn and, in order that none of the realism might be lost, a dozen cameras situated at various points along the lawn were used in photographing the various scenes....The piece was especially written for Miss Munson....She has subordinated her beauty to the skill, the charm and the magnetism of her dramatic art....The

story of "Purity" is one which gives Munson opportunities of unusual contrast. She is to be seen in roles ranging from the part of a simple everyday girl to the interesting fantasies of the sculptural poses.

"There are twenty players appearing in important roles in the production in support of Miss Munson, and more than 150 dancing girls under the personal direction of the Ruth St. Denis Dance Company. Both from a spectacular, daring and elaborate standpoint this new feature promises to outrival anything ever attempted for the motion picture screen." Insight into the creation of this elaborate production was given in 1928 by the scenario writer, Clifford Howard, in *Close Up* magazine. Of Audrey Munson's having been chosen for its lead he recalled:

"Munson...leaped into fame as a result of having been chosen out of a multitude of models to pose for the figure of the memorial coin of the World's Fair in 1915. Newspapers exploited her as the woman with the ideally perfect figure. At the height of her notoriety the president of the American Film Co. secured a contract with Munson to appear in a moving picture... and forthwith proceeded to whet the public appetite with advance notices regarding the forthcoming film....I hit upon the title "Purity"...and constructed the scenario

In her film, "Purity," Audrey utters the words of the Apostle Paul, "Unto the pure all things are pure," attempting to establish the story as a morality play while acting the dual roles of Purity and Virtue...mostly in the nude.

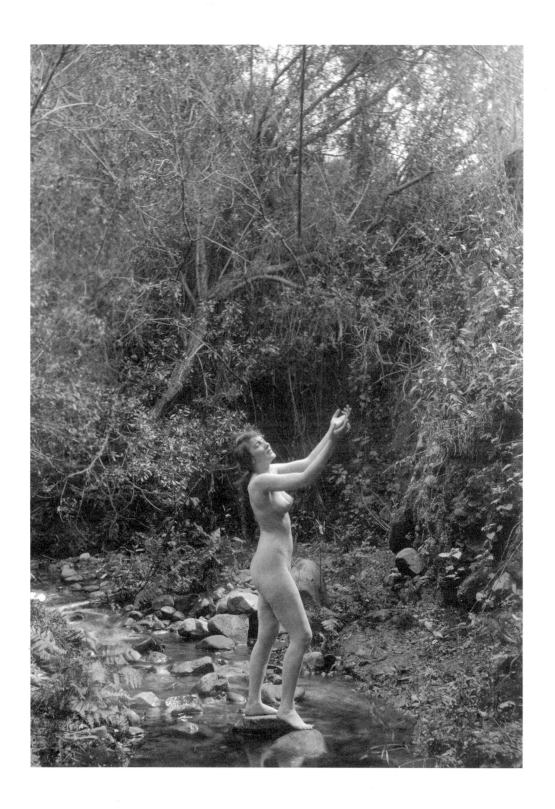

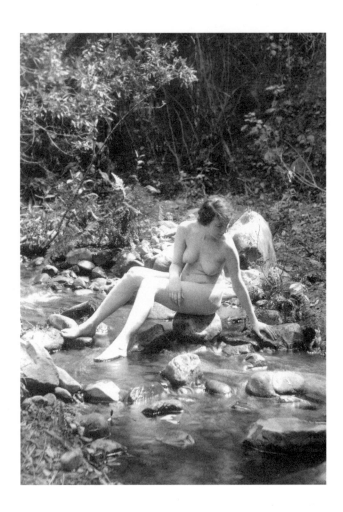

(for the double life of the allegorical figure Purity and Virtue, both played by Miss Munson) along highly poetic and idealistic lines....Whatever may be said of the outcome as a production of art, it fulfilled the company's expectation as a profitable sensation... and though it was the most costly film they ever turned out, by the end of the year they were more than half a million dollars to the good."

Howard went on to demonstrate the mixed opinions of the day: "Some towns forbade it and others frankly welcomed it. Critics unmercifully roasted it, and critics enthusiastically praised it and recommended it. Sermons were preached about it, pro and con. The old maids of both sexes who sneaked in to see it were becomingly shocked, while stout-moraled men and women openly extolled it....The motto of the film—*Garter honi soit qui mal y pense*—was resurrected from its classical limbo and hurled at the picture's detractors by those who saw in the film a work of beauty and a consistent fulfilling of its title."

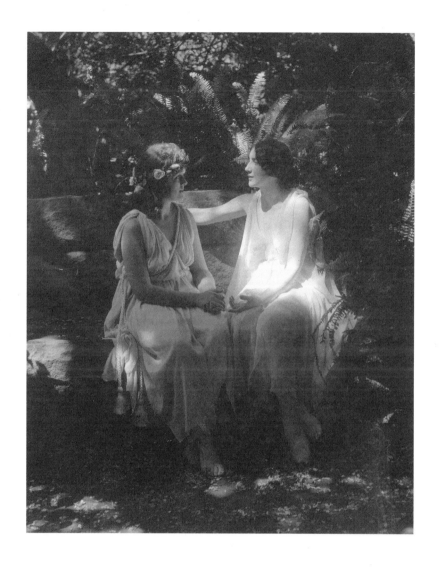

"Critics unmercifully roasted it,
and critics enthusiastically praised it.
Sermons were preached about it, pro and con.
The old maids of both sexes who sneaked in to see
it were becomingly shocked, while stout-moraled
men and women openly extolled it...."

— CLIFFORD HOWARD, "PURITY" WRITER,
Close Up MAGAZINE, 1928.

"Girl O'Dreams."

In 1917 the American Film Company of Santa Barbara, California produced Audrey's third cinematic effort. By some accounts it was filmed just after the extravagant "Purity." Once again, the star posed nude and the scenario focused on the romance between an artist and his model/love. The popularity or fate of this film is not recorded in existing film archives beyond a listing of the cast and a synopsis of the scenario, which on its final page is written:

"As darkness descends and the boat is no longer in view, Phillip turns back to the loneliness of his home. He enters his studio and then again in the dim light sees the figure of his favorite statue. As he watches it the statue suddenly moves, steps down from the pedestal and comes toward him. He is horror-stricken for a moment, then realizes it is no longer anything stone, but Norma herself, and seeing the love light in her eyes, he folds her in his arms."

In the early days of the cinema, as today, publicity was especially important in winning fans for a studio's contract stars as well as in promoting films. By the time Audrey's third film (her second for the American Film Company), "Girl O'Dreams," was in production, the studio's publicity department turned their attention to their latest discovery. The national press was provided with a variety of newsy topics on the star from her automobile driving lessons to her first plane ride. Audrey easily projected a "girl next door" image when appropriately clothed. Wholesome lifestyle photographs portrayed her relaxed living conditions during her stay in California. The *Detroit Tribune* ran this article in 1916:

"Audrey Munson, the noted artists' model who is now at work on a production in Santa Barbara was treated to an unpleasant surprise recently when she discovered the charming bit of surf into which she was wont to plunge each morning is infected with man-eating sharks. She had made it her business to obtain a bungalow with a fine sandy beach for a front yard, and it was not until she had enjoyed the surf bathing there for some weeks that she learned the proximity of the sharks. Now Miss Munson says: "Don't know anything about these man-eaters but I know a model who is not going to be fed to them."

Wholesome lifestyle photos portrayed Audrey, the movie star, in fan magazines. She easily projected a "girl next door" image when appropriately clothed.

"Heedless Moths."

Between the completion of "Girl O'Dreams" in 1917 and the 1921 production of "Heedless Moths," her fourth film, Munson found herself at the center of a scandal—the Wilkins murder case. Through several years of anguish and financial difficulty, she remained committed to making an impact on the rapidly expanding film industry and making a future for herself. She fought for a successful comeback from the unfortunate circumstances of the scandal which had tainted her career, none more devastating than the decision by the American Film Company to drop her contract.

"Heedless Moths," based on an incident taken from her recently published auto-biographical series of articles, was to be her "comeback" vehicle. Evidence alludes to the possibility that Audrey was never actually seen in this film, rather a look-alike, Jane

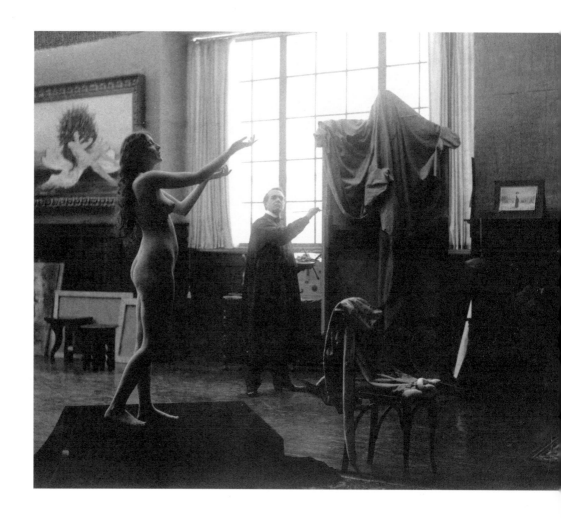

"HEEDLESS MOTHS"

A Robert Z. Leonard Production
Produced by Perry Plays Inc.
By arrangement with
Allan Rock

ωω

The unknown history of many famous masterpieces; the strange eccentricities and methods of artists; the distressing tragedies of the pretty models who lacked moral balance to safeguard them from the intimate atmosphere of the studios---as revealed by

AUDREY MUNSON

THE CAST

The Sculptor	Holmes E. Herbert
His Wife	Hedda Hopper
The Dilletante	Ward Crane
The Prey	Irma Harrison
The Sage	Tom Burroughs
AUDREY MUNSON	. .	{ Audrey Munson { Jane Thomas
and		
"The Spirit of the Arch"	. .	Henry Duggan

Thomas, played the entire part, artistic poses included, while Audrey remained at home in upstate New York and supposedly collected a fee of $27,000. In any case, in 1921 Thomas was sent on the publicity tour for "Heedless Moths" instead of Audrey, which later prompted Munson to file suit for $15,000 in damages against Perry Productions and the film's producer, Allen Rock.

When it came to the film itself, reviews were not at all kind. Motion Picture World, June 10, 1921, had this to say: "In this picture 'Heedless Moths,' Munson is showing back, front and sides....it's about how Audrey felt ennobled because a real sculptor allowed her to pose and how Audrey saved the sculptor's wife. No one on the program stood for the story. Maybe Munson wrote it herself...from an experience she would like to have had... 'Heedless Moths' is adapted from her published series, and produced by Alan Rock. All there is to this picture is Miss Munson's shape, undraped and unashamed, the nakedness of Munson in the film is a box office cinch. The farther away from New York the bigger the cinch....may her shape never wither!"

"Inspiration"

MUTUAL MASTERPIECE FILMS 1915

(RE-RELEASED AS "THE PERFECT MODEL" BY FLYING A FILMS, 1917)

───

A young sculptor dreams of finding a perfect model to inspire his work, but meanwhile is forced to accept substitutes. His three friends search the streets for the perfect woman and return with the waif-like, poverty stricken girl (played by Audrey Munson), who is soon recognized by the artist as the incarnation of his beautiful and innocent dream girl. The story continues along orthodox lines, telling how the model, despairing of winning the love of the sculptor, wanders off and becomes famous as an artists' model. At the end the young sculptor she loved discovers his love for her as well. After a discouraging search, during which the young sculptor visits all the famous pieces of statuary throughout Manhattan
for which she has posed, she is found, alas, bedraggled at the foot of the Maine Monument in Columbus circle. They are together forever, in marriage.

—MOTION PICTURE WORLD

"Purity"

AMERICAN FILM COMPANY 1916

───

The story is taken from Greek mythology. Purity wanders over the earth exerting a good influence on everything. She is loved by a struggling poet, who idolizes her. They both fall in love, but he is unable to sell his poetry, and marriage is impossible because of his poverty. Purity's wonderful beauty and grace of body is seen by an artist, who gets her to pose for an allegorical painting. She does it to get the money so that her sweetheart's poems may be published. She is successful and the lovers are united.

—MOTION PICTURE WORLD

In synopses of these films which appeared in popular movie magazines, the amusingly simple scenarios borrowed from classic themes all involved Munson in her life as the most recognized model in American art.

"Girl O' Dreams"

AMERICAN FILM COMPANY 1917

— · — · —

After the death of his young wife Phillip Fletcher, a millionaire and sculptor, makes his home on an uncharted desert island. Harry LeRoy a cad who is courting the widow Mrs. Hansen, desires the widow's convent-bred daughter Norma, and persuades mother and daughter to accompany him on a sea cruise. When the ship catches fire, Norma, abandoned by LeRoy and her mother in the confusion, is washed ashore on Phillip's island. Phillip clothes and shelters Norma, whose mind has become childlike from shock, and he uses her as a model for his sculptures. Through Phillip's friend, Jack, a photo of one of the sculptures travels to America, where LeRoy sees it and subsequently finds his way to Phillip's island. LeRoy tries to rape Norma, and in the ensuing struggle LeRoy is killed and Norma recovers her adult personality. Phillip, who is in love with Norma, returns her to the United States, but Norma does not board the boat, and Phillip, finding her posing as one of his statues when he returns to his hut, finally declares his love.

— FEATURE FILMS JOURNAL

"Heedless Moths"

PERRY PRODUCTIONS 1921

— · — · —

The story is about a modest little model who poses for the sculptor and inspires him—but their relations are perfectly pure. The model honors the man so much that when his wayward wife goes to the Libertine's studio, the model replaces her there so that the husband may never know the truth. What matters it, if the man, in a rage, then shatters the beautiful work for which she has posed. She has saved a home. Her noble act of self sacrifice overwhelms the Libertine. He marries the Prey, and they are happy for ever after. Only the poor model suffers—but she has made so many people virtuous and happy, that her joy must descend all things.

— DAILY VARIETY

The Wilkins Murder.

1919 saw the Munson women living in a boarding house on West 65th Street on the Upper West Side of Manhattan within close proximity to many of the artists' studios. The building was owned by a Dr. Walter K. Wilkins and his wife Julia. The couple had befriended the two women and Audrey and her mother had visited the Wilkins' home in Long Beach, Long Island. During the course of the friendship Dr. Wilkins had apparently fantasized a relationship with Audrey that went far beyond landlord and tenant. A love note from the Doctor to Audrey was found. Tenants claimed to have overheard the Doctor saying to Audrey, "You should never marry or you might lose your slim figure." It was Mrs. Wilkins who made the discovery that her husband had taken a fancy to the youthful Audrey, which was undoubtedly the reason she asked the women to leave. Some involved had been given the impression that the Doctor had actually offered to marry Audrey if he could get rid of his wife.

On the evening of February 27, 1919, Julia Wilkins was brutally murdered, her body found in the yard of the couple's suburban home. Dr. Wilkins blamed robbers for the crime, but circumstances pointed to his involvement, and he was arrested. Investigators wasted no time pursuing Audrey after questioning the other tenants in the boarding house about her hasty departure. Headlines across the country carried the news: "Syracuse Model Wanted in New York Tragedy" and "Actress Sought In Wilkins' Murder Inquiry."

Audrey and her mother had quietly slipped away from New York. To District Attorney Charles Weeks, this behavior was suspicious; he sought her whereabouts in the hopes of shedding light on the domestic relations of Wilkins and his murdered wife. He started in Syracuse by questioning Audrey's father, Edgar, who stated that he had no idea where the women were though he did know of their intention to leave the city.

The search for Audrey continued; articles across the country mentioned her name in relation to the case. Meanwhile, the two Munson women were found living in Canada having left the Wilkins apartment several weeks prior to the murder. On March 31, 1919, in Toronto, they testified that Mrs. Wilkins had asked them to leave because she had caught them cooking in their rooms. Satisfied with this explanation, Audrey was cleared of any connection to the unfortunate event. However, the country at large would be slower to forgive and forget.

SYRACUSE MODEL WANTED IN NEW YORK TRAGEDY

SEEKS AUDREY MUNSON IN WILKINS MURDER MYSTERY

trict Attorney Wants Girl to Cast Light on Domestic Relations of Family While She Resided at Physician's Home at Long Beach, L. I.

uietly slipping away from New k without even notifying her er where she was going, Miss rey Munson, artist's model and ion picture actress, is being ght by District Attorney Charles Weeks in the hope that she may w some light on the domestic tions of Dr. Walter K. Wilkins his murdered wife. Miss Munand her mother, who had lived Dr. and Mrs. Wilkins at their h house, left just a short time ious to the tragedy at Long ch, L. I. rs. Edgar Munson, second wife he father of Miss Munson, stated sday morning to The Journal that did not know where the girl and mother were. The last news e in a letter about a month ago which the girl stated she was ing the New York address and has not been heard from since. Munson said that the pair had living with the physician and all mail was addressed in his ver since the murder of Mrs. Wiland the authorities have scout he story of the doctor that his was killed by robbers, District rney Weeks h been seeking Munson and r celebrated hter without r Finally he aled to the newspapers that they wanted and asked aid in locat them. Although Miss Munson not returned to her former home 426 S. Salina st. for nearly two s, it was thought that some word t have been received. This was ed, however. e Syracuse model became fa s nationally when she posed for y of the statues used at the Pan -Pacific Exposition and for the t war poster, Liberty. Motion ures then offered still a greater and for a time she was widely ured in "Purity," "The Perfect el" and other films. Paintings photographs which revealed far e than certain minds regarded as limit of artistic propriety were ed in some cities.

from the town house of Dr. Wilkins in West 65th st. was a remark said to have been made to the girl by Dr. Wilkins, and whi h both Mrs. Munson and her daughter resented. Someone who overheard the remark informed Mr. Weeks that the physician said:

"Don't ever get married, because if you do, you will lose your symmetrical figure."

District Attorney Weeks wishes to learn from the pretty model just how much interest Dr. Wilkins displayed toward her and whether, and to what extent, it was resented by Mrs. Wilkins.

Mrs. Wilkins' body was exhumed from the Lutheran Cemetery, Middle Village, L. I., to secure her finger prints, to be compared with finger prints beside a doorway in the Long Beach house and in Dr. Wilkins' room. If they correspond, detectives assert, the latest theory that Mrs. Wilkins was murdered within the house will be strengthened. Dr. Wilkins has maintained she was slain near the garage while he fought some robbers in the house.

Thinks Murder Was Done Outside.

William J. Burns, the well known detective, who has worked on the case for the prosecution, expressed the conviction that Dr. Wilkins' statement that his wife was murdered out-of-doors was true.

"There is no question about that at all," said Burns. "The woman was murdered outside the house—in the yard."

Several persons have volunteered information to District Attorney Weeks that they saw and heard the accused physician and his wife quarreling the night of the murder. One claimed to have heard Dr. Wilkins say with emphasis that he "must have ready cash."

"I am sure there were no burglars in the house of Dr. and Mrs. Wilkins on the night of the murder," District Attorney Weeks declared. He refused to enlarge upon his statement, but it is believed to be based upon evidence unearthed by detectives.

SYRACUSE MODEL SOUGHT BY DISTRICT ATTORNEY

AUDREY MUNSON.

The case went to trial and Dr. Wilkins was convicted of the murder based on overwhelming physical evidence found at the site of the crime. He was sentenced to die in the electric chair but beat justice to the punch and hung himself in his jail cell.

The case was closed but the stigma of its unfair implications thwarted Audrey's many attempts at finding work. After being rejected by all that she had known, Audrey began referring to the situation as "the curse"—the cause of all her troubles. She shared her pain and sadness with *Daily Variety*, in 1920:

"The Wilkins case ruined my career. I'll never account for anything again" said Miss Munson. "At all events from loving and admiring me, the public seems to have grown to hate me. And I cannot help thinking that the feeling was fostered in some powerful quarters.

"I was released from my contract with the American Film Company. I was told that I was not needed for a new picture and that I was at liberty to take work anywhere. I made the rounds of the studios, but it was a vain hope.

"After I tried to find something to do in Toronto, New York City, Kansas City, Chicago and Detroit, I came home. I was brought up in Syracuse and thought I could get rid of this horrible bugbear of suspicion here."

Local papers picked up the story, publishing it in all its sad detail, and describing mother and daughter as living in a small room, cooking their own meals over a gas burner, and repairing the scanty remains of what was once a fabulous wardrobe. Katherine was reduced to selling kitchen utensils door-to-door to keep them going. After failed attempts to find work, Audrey's personality showed outward signs of insecurity, as her life lacked not just an income, but direction.

Her mother later expressed it differently saying this was the time when Audrey began to lose her concentration, became increasingly nervous, fearful, and sadly, was no longer at ease. The "world's most famous model" was fighting to recover her fame, her dignity, and eventually her life.

In 1920, *The Syracuse Journal*, which over the years had printed sensational stories on Munson, announced her "comeback" in a film to be called "A Thousand Faces," produced by Metropolitan Pictures Corporation of Boston. The *Journal* claimed some involvement in the match-up as a result of having printed stories about her desire for roles in upcoming films. The *Journal* enjoyed its position in making the match and a blow-by-blow accounting of Audrey's film offer followed. This film, if it was actually made, did not star Audrey.

Once again, she expressed "a mysterious conspiracy—a curse" had thwarted her progress and left her penniless and rejected by her supporters and admirers. Audrey attempted to regain her status through her own efforts by announcing the start of her own independent film production company. The goal was to raise money by selling shares, produce films for the growing international film market, and gain control over profits. Having been a mere hired hand for "Inspiration" and "Purity," both astoundingly profitable films, she was hoping a share in profits would secure her own future at long last.

The Rochester-based company did not achieve its aim. No films were completed and legal battles ensued. Of the one film attempted, "The Madonna of the Garden," the headline in a New York publication read, "Film Partly Done." The Audrey Munson Producing Corporation had completed a portion of the film in which "the Madonna is an Indian princess, starring Audrey taking her classic poses." It continued, "Several thousand feet of film have already been shot in exterior scenes taken in San Antonio, Texas and in Cliffside, New Jersey. But Pierce Kingsley, director of this silent drama, desires to obtain more "atmosphere" by taking outdoor scenes on the river gorge here and in the vicinity of Portageville." A heavy snowstorm would also be required in the weeks to follow. No further mentions of this film have been found. Years later, Audrey would blame her manager for its failure and for absconding with her royalties.

QUEEN OF THE ARTISTS' STUDIOS

1920-1923

✳ *Prohibition began.* • *Al Capone ran Chicago* • *People explored their subconscious repression through "ink blot" therapy created by a Swiss doctor named Rorschach.* • *The Dadaist movement in art challenged popular notions with shock value.* • *Tutankhamen's tomb was discovered.* • *The Electrolux vacuum cleaner was the newest household innovation.* • *Joan of Arc was declared a Saint.* • Vanity Fair *magazine coined the name "Flapper" for a woman who drank, smoked, wore short skirts, bared her arms, bobbed her hair, and stayed out all night—without feeling guilty.* • *"Ain't We Got Fun" was not only a popular song but a social statement.* • *Gershwin composed "Rhapsody in Blue," the Monkey Trials challenged Darwin's theory of evolution, Lindberg crossed the Atlantic solo.* • *"The Jazz Singer" hit the screen then silent no more.* • *Penicillin was discovered.* • *Winnie The Pooh and Mickey Mouse captured hearts around the world.* ✳

AUDREY'S OPPORTUNITIES waned, and she retreated to a life of recalling her days in the studios through a popular series of autobiographical newspaper columns.

PREVIOUS PAGE

Memorials were some of the most important commissions of the time.
Trask Memorial, Saratoga Springs, New York.
Daniel Chester French sculptor.

By the fall of 1920, the Munson women were penniless, desperate for work, and living in a tiny farmhouse on the outskirts of upstate New York. The white clapboard house had been donated free of rent by Audrey's concerned father. Out of the limelight and wondering what to do with her life, the line between fantasy and reality was beginning to blur for Audrey.

Years had passed since she, as pure and perfect beauty, had easily won top modeling assignments in the artists' studios with her innocence and breathtaking poses. Now almost 30 years old, she was far from the state of her former glory. And, as evolution demands, even the world of art had moved on from the allegorical sculptures of the Beaux Arts period to the deconstructed realities of abstract art. Audrey never understood "Abstract Art" and thought it to be "ugly." Films, too, were becoming more modern and sophisticated. Audrey was simply, and sadly, out of style.

Though hidden from view, the effects of unfulfilled hopes and dreams created struggles in Audrey's psyche. None observed her shattered state and nerves more closely than her mother. Katherine was deeply wor-

ried. Audrey thought up outlandish schemes that appeared to be the stuff of movie scenarios to end the "curse." She planned to place an obituary for herself in the papers hoping to start life anew. She wrote letters to President Harding demanding that a persecution plot against her be stopped by a vote of Congress and later volunteered her services to the government as a German-tracking spy girl.

As their situation grew more glum, did Katherine once again look back on the Gypsy's predictions? "She will have fame and fortune...and lose it all." Had the gypsy's somber prediction come to pass? And then, in groping for good news to tell her daughter, did she remember one part of the prophecy which could bring happiness and stability to her only child? "Seven lovers she will take, the last one she will wed." Would her fate be so beautifully sealed and thus bring to a happy end their fifteen year coast-to-coast journey? Audrey—the girl with the charmed existence—was suddenly inspired to seek her perfect mate.

In summer 1921, still displaying a soft youthful countenance and widely remembered as an actress and model, Audrey was

determined to right her life and begin again. Soon, the roller-coaster-ride of the recent past would be forgotten as she entered into her new role as perfect wife. But, with typical Munson melodrama, she announced her intention to the press knowing its power over the masses. What may have been an innocent act in hopes of finding a fairy tale romance resonated with some as just another thinly-veiled personal promotion. In her well-thought-out request for an Adonis, "....of 'physical ideal,' well proportioned, 5'5" to 6'4" and weighing 120 to 240," the Syracuse "Diana" promised to personally write each candidate. According to follow-up articles, 209 answers were received, 208 return letters said, "thank you very much, but...." The process took over a year.

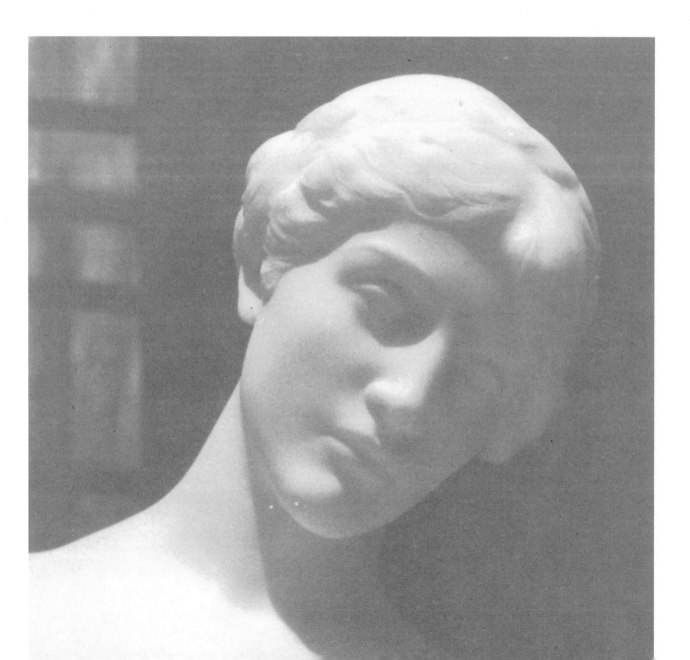

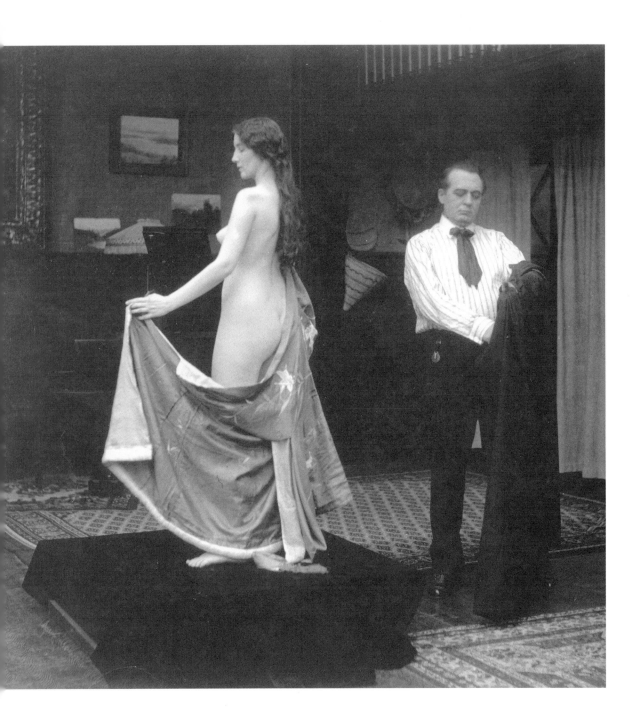

Days of Glory.

In early 1921, Audrey returned to her days of glory, if only in the form of newspaper pages filled with photos and written remembrances of her former career The series, "Queen of the Artists' Studios," was published in the *New York American* newspaper in New York City. Through syndication they were shared with millions of readers. Sundays, in twenty weekly installments, she took art lovers and the merely curious on tours into the obscure world of fine art, among the famous artists in their studios, sharing in great detail the model's life for which she earned her title, and a fair amount of money. Ranging from poignant to self-aggrandizing, her recollections began with her awkward first nude moments and went on to describe her influence over the artists as their creative muse. Readers also explored the series for personal beauty tips and gleaned her advice on entering the modeling profession. But Munson added warnings by telling the sad ends of girls who fell pray to the evils of "over indulging and living the high life" or worse, the "seamy side" often associated with the Bohemian artists.

On the lighter side, after reading Audrey's claims that grace, dignity and "thinking positive and pure thoughts" were the way to the perfect body, women throughout the land must have quickly taken up home training with the program Munson prescribed. Some of these ingenuous and often-charming suggestions included: spending hours picking up marbles with the toes as a method for developing perfect feet; never wearing high heels to protect the shape of the hips, thighs and legs; avoiding all makeup; and especially, doing no muscle-developing exercises. Munson also advised women to understand the movement of their bodies by removing all clothing, standing in front of a mirror and learning to walk. Once clothing was again added, the woman would remember she was moving her graceful flesh across the room, the clothing merely a cover for the perfection beneath.

Many readers practiced her beauty regime faithfully, but to make it more interesting the amount of "weekly dish" was increased. So, an amusing, though unnamed, cast of characters entered the

"In position, holding a pose while a sculptor or painter worked, I thought of myself only as a model, a mere piece of human flesh. The moment the artist dropped his brush or mallet or molding tool I became the human young woman again, ashamed to have my body seen. All my sense of modesty came back to me at once. And all through my years as the "Queen of the Studios" this same feeling came to me the instant an artist said after a pose, "now you may rest a while." As this feeling came to me I then rushed behind the screen, blushing furiously, and got into my clothes." — AM

series, including love-sick men who fell for beautiful female statues hoping to marry the *poseure*, and society women who posed for the famous artists—even paying less scrupulous sculptors to create their likenesses. Naturally, after the wealthy women left, Audrey would be called in for a proper pose to finish the work. The artists' eccentric personalities added greatly to the 20-part series. At times her accounts sounded like fantasy. However truthfully she told the tales though, her insights into the world of the artists became popular newspaper fair.

Audrey recounts that at one time there were no less than 30 likenesses of her in the Metropolitan Museum of Art in New York City. Many of the creators of these works, though famous then, are at present virtual unknowns, their works no longer in the public view. Some pieces are simply lost, others rest undisturbed in museum storerooms, still others are prized possessions in private collections.

Sadly, as times changed, commissions involving allegorical figures were fewer and the need for the live model's pose became less. In this poignant admission of 1921, Munson expresses the reason for the sorrowful close of her charmed career:

"I went to the artists for whom I had posed. They were kind, but actually there was no place for me. I had posed for them so many times they had hundreds of sketches and rough drawings of my figure, my arms, the turn of my head, so that they really had no need for me anymore."

Audrey Munson would always be reigning "Queen of the Artists' Studios" even if only by self-proclamation.

Stained glass windows for the Church of the Ascension, New York City, said to be designed after poses made by Audrey.

By the "Queen of the Artists' Studios"

The Story of Audrey Munson — Intimate Secrets of Studio Life Revealed by The Most Perfect, Most Versatile, Most Famous of American Models, Whose Face and Figure Have Inspired Thousands of Modern Masterpieces of Sculpture and Painting.

Of the two hundred and more of the foremost artist and sculptors of the United States, for those masterpieces she has been the inspiration, probably each one would give a different answer to the question.

Francis Jones found in her face the purity and sweetness he needed for the stained glass angels in the Church of the Ascension in New York; and the great MacMonnies found in her the inspiration for his voluptuous bacchanalian Sybarite. William Dodge used her bubbling vivacity for the "Spirit of Play" in the Amsterdam Theater frescoes and yet her serious dignity won for Adolph Weinman the prize in the competitive statue to adorn the top of the great New York Municipal Building— and there Audrey Munson stands as "Civic Fame," cast in copper and gilded, a gigantic figure twenty feet tall.

Sherry Fry could find no one to typify maidenly innocence so well as Miss Munson and his appealing "Maidenhood" hangs on the walls of

the Metropolitan Museum of Art. So, too, Konti modeled from her his famous "Widowhood," Pietro his "Suffering Humanity," Wenzel his charming but frivolous "Madame Butterfly," and Adams his impressive and serious "Priestess of Culture."

From the carved caryatids which support the mantelpiece in the main saloon of Mr. Morgan's yacht, the "Corsair," from the exquisite tapestries of Herter in the George Vanderbilt home, from the souvenir dollar of the San Francisco World's Fair, from the smiling water nymph on the edge of the pool in John D. Rockefeller's Tarrytown estate, from the stone angels on a hundred churches and cathedral altars, from 24,000 feet of mural decorations and scores of groups of statuary at the Pan American Exposition, the figure of Audrey Munson looks down upon the passing multitude and adorns the homes of patrons of art.

What is it that has made Miss Audrey Munson the undisputed "Queen of the Artists' Studios" for more than ten years?

Throughout the length and breadth of the US, in libraries, museums, private galleries, town and country residences, public buildings, churches, bridges, fountains, public squares and parks and private lawns and estates the most famous of all American artists' models is seen in endless variety.

Audrey Munson has written the story of her life, the incidents and episodes behind the scenes in the studios, the unknown history of the inspiration of many masterpieces in public and private art collections, the strange eccentricities and methods of the artists—and the distressing tragedies of the pretty models who lack moral balance to safeguard them from the perils of the intimate atmosphere of the studios. Audrey Munson's fascinating story is told from week to week on this page.

Excerpted from Audrey's 1921 syndicated newspaper series.

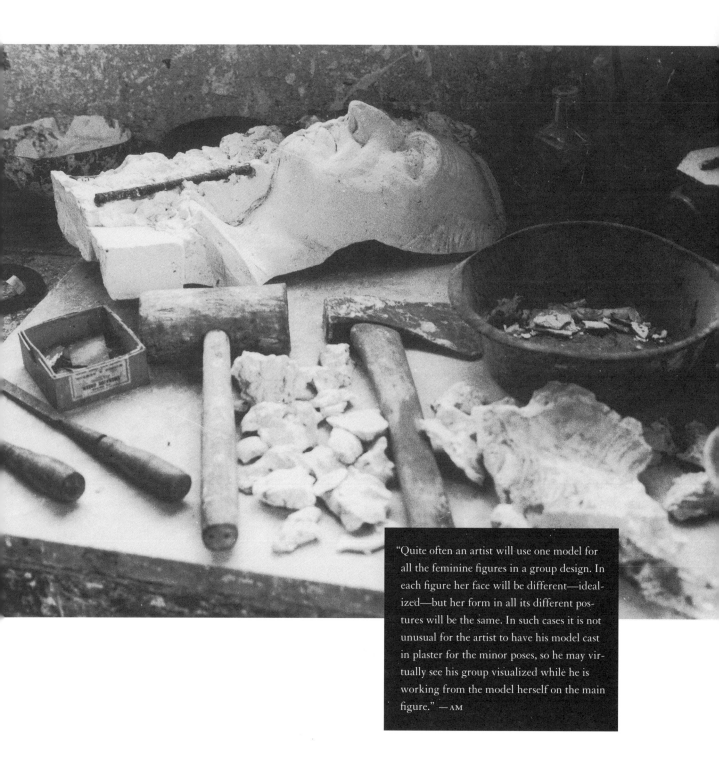

"Quite often an artist will use one model for all the feminine figures in a group design. In each figure her face will be different—idealized—but her form in all its different postures will be the same. In such cases it is not unusual for the artist to have his model cast in plaster for the minor poses, so he may virtually see his group visualized while he is working from the model herself on the main figure." —AM

Flesh of White Plaster.

"The process and the attending incidents of being transformed into a plaster cast are not at all pleasant, even to an experienced model. The shops in which the molding is done usually are mere workrooms, not studios, and frequently belong to house stone cutters and bronze molders.

"The model first puts aside her clothing and steps upon a low stand in the center of the workroom. A workman then paints her entire body with a mixture of oil and grease—she takes a veritable bath in this heavy liquid. Then she assumes the pose the artist desires, under his guidance. When the position is satisfactory to the artist the casting is begun.

"Close to where the model stands workmen mix small batches of plaster of Paris to just the right consistency. Working simultaneously, two other workmen apply this warm plaster, beginning at the model's feet. The plaster is literally slapped onto the flesh first and patted in with the hands, and then other layers are put on until the model's feet are firmly fixed in quickly solid-ifying masses of plaster eight to ten inches thick.

"The workmen have to work fast, as the plaster dries very quickly. More must always be added before the last handfuls put in place have become solid. The coating goes on up the body from the feet until, after a few moments, the model's feet, legs and torso up to her throat are blocked in by a shapeless mass that reminds one of a large snowman beginning to melt.

"If the arms are outstretched in the pose, tables have been built up to serve as a rest for the plaster when it is applied to the arms, as the girl would be unable to keep her arms out if she were compelled to hold up the weight of the mold. When it comes to covering the fingers the work is very delicate, as an artist, having shaped his model's fingers into the position he requires, wants them reproduced in just that position. And yet the first coating of plaster must be slapped onto each finger and then the outer coatings, applied around the whole hand without interfering with the slightest crook of the finger.

"Imprisoned [in the plaster cast], I felt as if all the heaviness of the universe were pressed about me, slowly crushing me to death."
—AM

"The most unpleasant experience of the model comes when the casters enclose her face and head. A silver tube is put between her lips that she may breath through it, and cotton is stuffed into her ears. She must close her eyes and have an extra coating of oil and grease over their delicate lids. Then, so quickly she might well be startled, great handfuls of soft plaster are pressed against her face, more against the back of her neck, and one workman stands on a table beside her and pours plaster from a bucket over the top of her head.

"A moment later the illusion of the snow-man is complete. There stands in the center of the workman just a rough mound of plaster two or three feet thick from the floor up to a foot higher than the top of the imprisoned model's head. The mass sways a bit as the model attempts to relax in her "case" and a workman throws his arm around the fast solidifying mass to keep it from toppling over, model and all.

"Inside, the girl cannot move so much as the tiniest fraction of an inch. She is virtually part of the plaster itself. It is nothing less than a horrid sensation. I have tried to draw a full breath through my silver tube, only to find that I could not—there was no room inside of me for more than just the amount of air I had been breathing while the plaster was being put on. And once I was almost strangled because the workman slapped the plaster onto my stomach and chest while I was exhaling a breath and it hardened into place a moment later while I was again exhaling, giving me no room for expansion with the next intake of air. I had to breathe in little jerks until the mold was

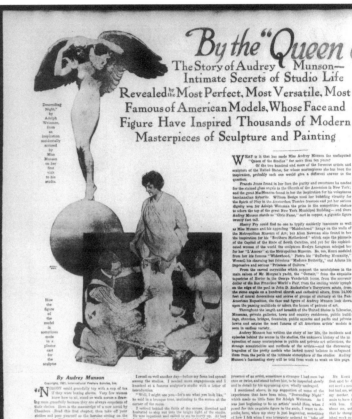

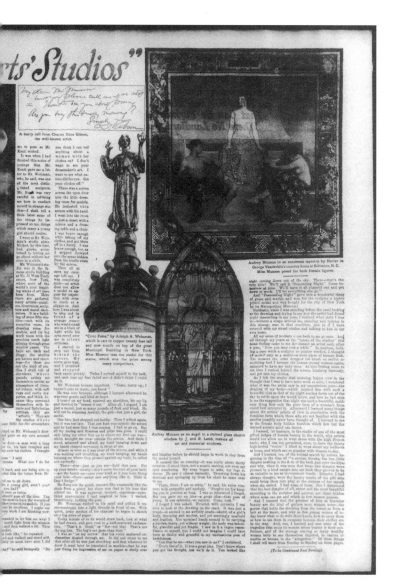

complete. Imprisoned in this way, I felt as if all the heaviness of the universe were pressed about me, slowly crushing me to death.

"When the plaster all has solidified then commences the process of removing the mold from the model without hurting her more than is necessary. First the face is pulled. They cut through the plaster and break it away from the face and head. The plaster comes off in irregular, broken lumps, some of it is almost in crumbs, and yet each tiny piece must be carefully preserved, laid on the floor in such a way that the pieces of the face mold are assembled as they come off in one piece.

"The face of the model cleared, the workmen begin with little hammers and chisels to break off the plaster from the rest of the body. They start at the throat and hammer the mass off in as large chunks as possible. Each piece is put carefully in place on the floor.

"At last the plaster has all been knocked off the model, in small and large pieces, and these pieces assembled on the floor in groups representing a part of the girl's anatomy. Now the model is through. She runs into a bath or warm water in which there has been placed some soda to cut away the grease. She is rubbed down and soon is refreshed and none the worse for her experience."

Then, the pieces are refitted, and little by little, fresh plaster fills the hollow mold until the replica of the model is completed. The plaster form, once again is hammered off, revealing the perfect replica, flesh of white plaster, the plaster pose is later cast in bronze or sent to the stone carvers for reproduction."

111

AUDREY'S PRIZED DIMPLES.

"Last week on this page I mentioned as amongst the possessions which helped make me the most sought after model in New York and California, the dimples in my back. It was Mr. Konti, the famous sculptor of "The Three Graces" and Mr. Scarpitta who did many notable works now in various museums, who discovered in my two dimples that which has been sought by sculptors since they were discovered in the pink and beautiful back of Aphrodite.

It was while I was posing for Mr. Scarpitta that Mr. Konti came into his studio one day and found me on the pedestal.

"I see you have my model," he said to Scarpitta.

"Yes", replied the latter, "and I'll wager you like her especially for the same reason—the dimples."

"You are right—I know of no other model who has them."

These conversational asides were very interesting to me. I was "in position" and could not move—nor ask a question. I wondered what they meant by "the dimples"—I didn't know I had any. While I was resting I asked Mr. Scarpitta what he meant.

"Don't you know? Why, those dimples in your back. Few women have them; they are natures rarest and most attractive beauty spots. I have never had a model whose complete back I could copy without suggesting a touch of delicacy, no matter how beautiful her lines.

"But two dimples, resting on either side of the hips in the back, seem to rob the most unattractive part of the feminine form of it's unrefinement—increase it's grace and symmetry, and above all, the daintiness which takes away the effect of boyishness from lean hips. Guard those dimples my girl, and if you ever see them going—cut out the apple pie!"

"I learned of the eternal search by artists beginning in the time of the ancient Greeks, for two little dimples nestling in the flesh of the back just over the hips, and why, when it was seen that two dimples were pressed by a kind nature into my back they proved to be as valuable to me as government bonds."

—AM

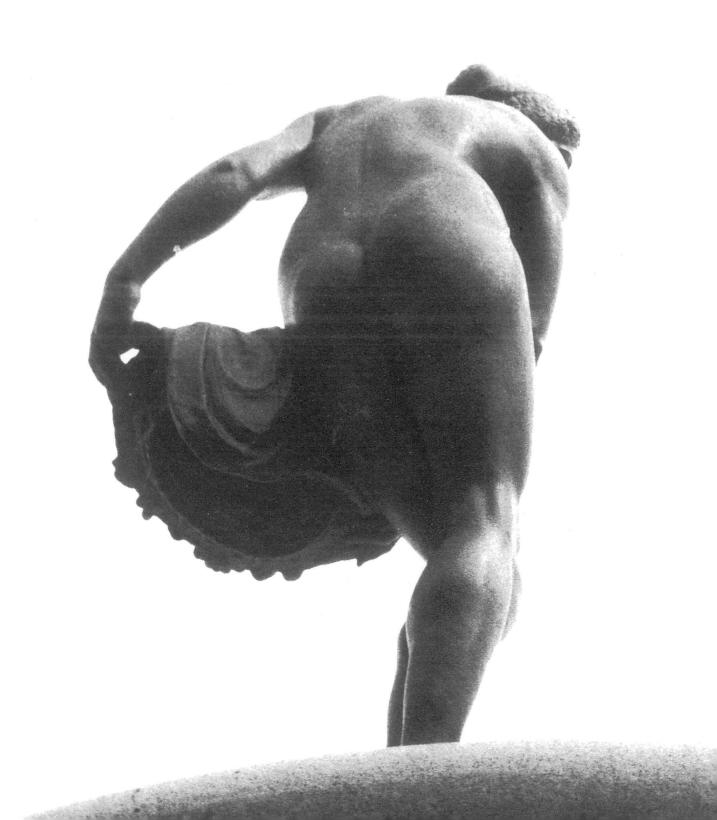

A Perfect Male and a Perfect Female Model are posed together. These two models held this pose for 15 minutes at a time for five weeks while sculptor Evelyn Longman completed the work. "Consecration," originally a plaster for the P.P.I.E., is now displayed in bronze at the Wadsworth Athenaeum, Hartford, Connecticut.

A Perfect Male
and a Perfect Female.

"When the artist tells the male model that he must appear nude, to him that means nothing. It does not shock him as it does the sensitive, inexperienced young woman just becoming a model.

"But when he steps upon the posing stand he is awkward. The feminine model at first is shy and embarrassed and uncomfortable, but she is not awkward. I have known some models who took on an added poise and greater appearance of naturalness and comfort when they had prepared themselves for the frankest of poses. The man, however, is never fully comfortable.

"The feeling of the male model is of course magnified when the artist is a woman. Mrs. Whitney, Miss Longman, Mrs. Ladd and others who so frequently employ male models often are much perturbed when a new model is engaged for a statue. They know that many days will be virtually wasted in patiently waiting for the model to become used to them. I have known Mrs. Whitney to spend a week sketching in clay a new male model without even attempting to start the work for which he was engaged—just to give him time to find his composure. An artist does not like to work on a model who is not wholly at ease.

"It is very trying to both models, however, when a young woman and a young man are engaged by a sculptor to pose together for a group. In such a situation there is the embarrassing situation of a man and a woman, neither of them known to the other, brought together under the most unconventional circumstances, the natural embarrassment of each emphasized to the highest degree, and yet each one of them fighting down any inclination to rebel or any chance discovery of their secret repulsion. The artists' model is always fearful of not pleasing his or her employer. Both the girl and the man try, in such situations as that above, to repress any shyness and mental distress, and appear before their employer as wholly unconscious of anything out of the ordinary."

A Venus with Arms.

When a summons from the great sculptor Karl Bitter—a native of Austria—arrived at Audrey's flat it was not to be ignored. Upon reading the cryptic invitation she went immediately to his large and active studio overlooking the Hudson River in Weehawken, New Jersey.

The beloved Queen of the Netherlands, Whilhelmina, wanted a Venus, preferably similar to the famous Venus de Milo of 150 BC which stands, armless, in the Louvre. But she was bothered by the original's lack of appendages. Thus, the request went out for an "armed" Venus, and Bitter was her choice to fulfill the sculptural commission. In her newspaper series Audrey told the strange tale.

One morning, just as I was leaving my apartment to keep a posing appointment with another artist, a telegram was handed me. It was a terse message—"I need you very badly at once. Please come today." And it was signed by a magic name—the sculptor Karl Bitter.

A summons from Karl Bitter was not to be disregarded—even if there were other appointments with lesser artists in the way.

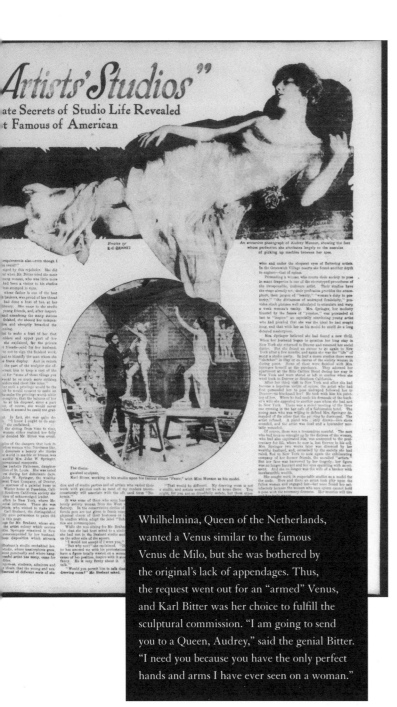

Artists' Studios "
ate Secrets of Studio Life Revealed
t Famous of American

PHOTO BY
E. C BENNET

An attractive photograph of Audrey Munson, showing the feet
whose perfection she attributes largely to the exercise
of picking up marbles between her toes.

The distin-
guished sculptor,
Karl Bitter, working in his studio upon his famous statue "Peace," with Miss Munson as his model.

Whilhelmina, Queen of the Netherlands,
wanted a Venus similar to the famous
Venus de Milo, but she was bothered by
the original's lack of appendages. Thus,
the request went out for an "armed" Venus,
and Karl Bitter was her choice to fulfill the
sculptural commission. "I am going to send
you to a Queen, Audrey," said the genial Bitter.
"I need you because you have the only perfect
hands and arms I have ever seen on a woman."

He was the foremost of all the world's sculptors. His studio filled a beautiful building he had erected on the banks of the Hudson close to West Point. Queen Whilhelmina wanted a complete Venus de Milo to stand in her ante chamber and help her decide questions of state. It was to Bitter, in New York, that she sent her royal command.

When I appeared at Mr. Bitter's studio he took my coming as a matter of course. He did not ask whether he inconvenienced me or not. He knew his request was a command among all models.

I am going to send you to a Queen, Audrey," he said genially. "I need you because you have the only perfect hands and arms I ever have seen on a woman. I am going to add you to Venus."

The next three months I posed every morning for Mr. Bitter's Venus. Often he did his work directly into the marble, carving with his own chisel. This time he molded in clay. I wonder if Queen Wilhelmina knows how her Venus was made?

When I was ready to try my first pose, I dropped my robe, and climbed onto a stand fixed in the center of the great room and cov-

ered with red velvet. Behind me an assistant draped a black velvet curtain so that my form would stand out against it in sharp relief. Mr. Bitter clapped his hands and his students— there were at least a dozen of them working on different things about the studio—dropped their chisels and cleansed their hands of clay and gathered around.

Now, then, Miss Munson, give us your idea of what the Venus de Milo was doing with her hands and arms," he commanded. I took my position. "What have you to say, gentlemen?" Mr. Bitter asked.

The young men walked around me. One thought my elbow was not bent right. Another declared my shoulders were not square enough. One decided my forearm was not at the proper angle with the upper arm of the original Venus. One young fellow frankly said he thought my arms were too lean for Venus—that Mr. Bitter should get a model who had more fat distributed about her.

Others said things which should make some women indignant. I, however, simply did not listen to them. I awaited Mr. Bitter's comment.

For more than two weeks the students worked several hours daily at separate mounds of clay.

When each Venus was completed to the master's satisfaction—each a different view of me, a different position—the platform on which they had been shaped were wheeled into the center of the great room, and Mr. Bitter held a 'post-mortem' over them.

Now the master himself started to work, on his own mound of clay. He posed me from the sketches his students had made—making sure I caught the exact angles and positions fixed in the clays. Then he worked directly from me. A pose was held for ten minutes, then there were fifteen minutes rest.

At last the clay sketch was finished. Then began the transfer into marble. Mr. Bitter did this himself. He had brought from Italy the best and clearest block of marble his agents could find—a beautiful block of shimmering white, which seemed almost to be onyx. I remained at the studio during the month occupied by him always ready to take the pose if he wished to refresh his memory, or to alter something in the sketch.

It required several weeks to properly crate the beautiful marble. Mr. Bitter superintended this work himself and he sailed for Holland on the same boat with the statue. He was present at the unveiling ceremonies in the royal palace, and was decorated by the Royal Museum and by Queen Wilhelmina personally.

It is said by those who are familiar with the moods of the Dutch Queen that she is accustomed, while waiting for her ministers or resting during a royal reception, to sit in front of her majestic Venus and seek inspiration in the benign immutability of its classic countenance for her own most regal moments. This ancient queen of a realm of love typifies to this Queen of a sturdy little modern kingdom the beauty and humanness which she encourages in her own people.

Perhaps in all the world, whenever I look down upon many millions of people every day and silently witness many stirring scenes and momentous tableaux, I occupy no prouder state than that which is mine in the intimate chamber of this much admired Queen. For the hands and arms of this Venus are mine.

Bitter had previously moved his family to the city when his children came of school age, and he divided his time between New Jersey and an elegant new apartment on West 77th street near Central Park. He had custom designed an airy 400-square foot art studio. It was here that he had finished his last work, "Pomona," for which Audrey posed. Feeling rather jubilant over the completion of this piece, Bitter celebrated that evening by taking his wife to the opera. Upon leaving the theater, an out-of-control vehicle ran into the couple. Mrs. Bitter fell safely between the wheels but Karl Bitter was left mortally crushed. Isidor Konti, his schoolmate from the Vienna Academy and lifelong friend, was asked to do the sad duty of overseeing the final casting of "Pomona."

The Perfect Form.

Take any statue and study its many parts, separately. What appears before you, Munson would advise could be a grand illusion. In days gone by, when the perfect form was constantly sought, each artist of his or her day obsessed on finding a prize Phryne—the Greek courtesan of perfect beauty and form, famous as being the muse of Praxytilies. Once discovered and standing nude in his studio, the artist would take his living goddess and set her into the poses he had dreamed up for his commissions. Audrey Munson, though Phryne to many artists, was sometimes only a segment of the final work of art. Many times, the face of the artists wife, daughter, sister, secret lover or simply a visage that appeared in the minds eye would take the place of the models actual facial features.

Munson personally advised one gentleman who had fallen hopelessly in love with a particularly beautiful statue, desiring to meet its model in the flesh:

You have fallen in love not with one young woman, but half a dozen. That marble smile was copied from the piquant face and rosy lips of one model famous for just those details; the shapely shoulders belonged to a girl whose legs were crooked; the arms were those of a young woman whose hips were helplessly disproportionate; while the hips of the carved figure had been taken from a model who never posed for bust or shoulders, because in these particulars she was unattractive. The long tapering limbs, knee cap and calf properly touching and ankles in true proportion to the thigh and knee were those of a young woman who worked behind the counters of a department store by day.

"Maidenhood,"
Brookgreen Gardens,
Pawleys Island,
South Carolina,
Sherry Fry sculptor.

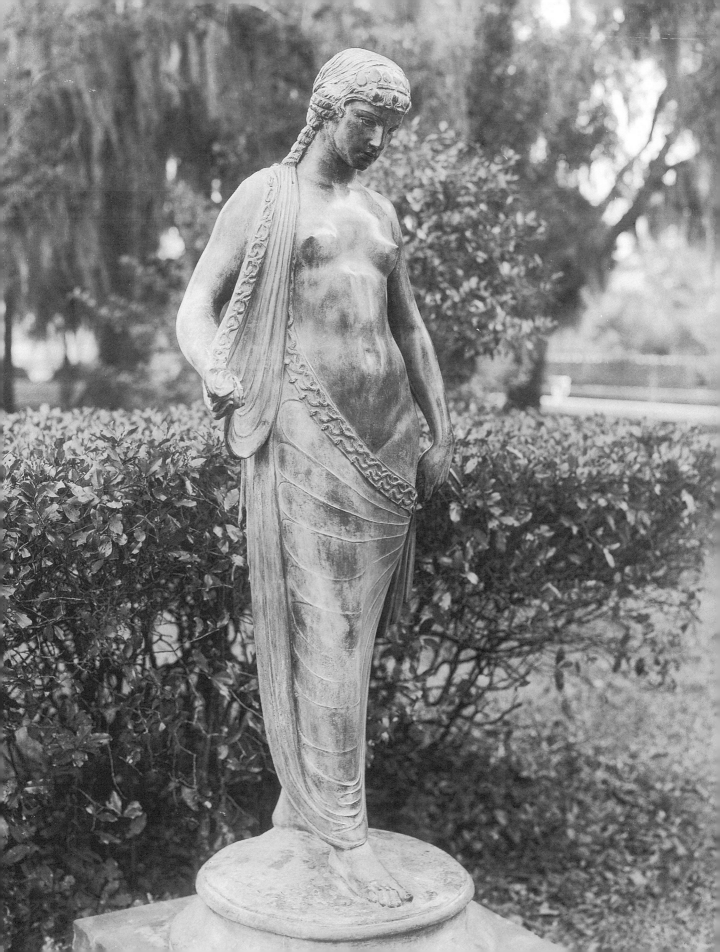

Audrey to wed in June.

An April 1922 edition of the *Syracuse Herald* delivered a message of glad tidings to all of Audrey's followers. She would wed in June, and take as her beloved husband a former aviator named Stevenson from Ann Arbor, Michigan. The glowing bride-to-be said she was expecting that her betrothed was coming to Mexico and she hoped they could be married in England.

When asked, in that interview, about her vocation, she said she would perhaps consider a career as a concert pianist, but all she really wanted was to perform the role of dutiful wife, which would make her life "richer by far than all the laurels of a successful career in art." The question was asked, "Is he your perfect man?" Audrey replied, "Really, I do not know. I do know, though, that he is perfect as the eyes of the heart see him. That is enough for me."

On the afternoon of May 27th, 1922, a telegram was delivered to Audrey's little farmhouse in Mexico, New York. The contents were never revealed. But that evening Audrey Munson dropped four tablets of a cleaning compound, bichloride of mercury, into a glass of water, drank the liquid, then lay down to wait for death.

She was discovered by her mother, who summoned the neighbors. Quickly, they administered home remedies to neutralize the effects of the poison. By her bedside Katherine found a loaded pistol her desperate daughter intended to use to finish off the job if the poison had failed. The doctor who treated her said Audrey would recover. The next day Audrey was apologetic, saying she regretted her actions and now, more than anything, "wanted to live."

No one knows what was in the mysterious telegram which seemed to have set Audrey into a frenzy of despair, though it was assumed her fiancé, Stevenson, had canceled their engagement. Audrey never heard from him again, and when a local paper tried to track him down, no such man was found to have existed.

Newspapers across the country made mention of Audrey's attempt to end her life. Many focused their reports on the melodrama of her misfortunes rather than offering up words of sympathy for the "Queen of the Artists' Studios." Was she quickly becoming an unpredictable "queen of drama" instead? Was this just another chapter in a trumped-up Munson saga— the tale of a small town girl whose head was filled with fantasies, and her mother, a beautiful divorced woman, grown bored with everyday reality? Were they, in fact, on a delusional journey of their own making?

Audrey's suicide attempt, her recovery, and her new found will to live are considered the last chapter in her public life. However, just two months after the suicide attempt, in July of 1922, a story appeared in *Movie Weekly* magazine. Her sad story, which dominated the front cover of the popular pulp reporter, told a tale not only of financial woe and victimization, but of the fantasy character of Audrey, the German-hunting girl spy. That Audrey could be capable of such revelations to the press after her traumatic personal incident just two months prior seems to negate her despair. The story read like a movie script, with modeling and mayhem, spy adventures and paranoia, gypsy predictions and, of course, Audrey at the center, posing nude.

Was she distraught—reaching out for help or was she thinking of the sale of yet another story of her life to yet another film producer? No one knows, but the line between reality and fantasy seems to have been crossed. And though Audrey acted as if she knew how the worlds of media and film operated, her own true emotions eluded her. Her inner world was crumbling.

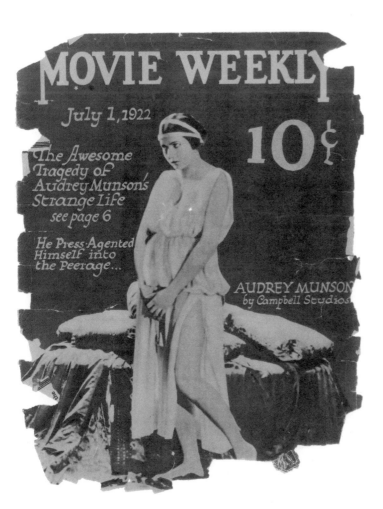

The Awesome Tragedy of

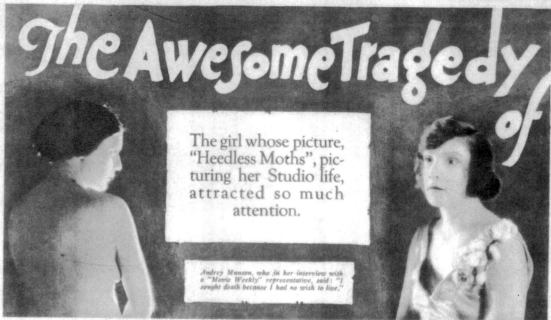

The girl whose picture, "Heedless Moths", picturing her Studio life, attracted so much attention.

Audrey Munson, who in her interview with a "Movie Weekly" representative, said: "I sought death because I had no wish to live."

EDITOR'S NOTE: This is the first of two instalments of "The Awesome Tragedy of Audrey Munson's Strange Life." In this instalment, a "Movie Weekly" representative, after an interview with Miss Munson following her unsuccessful attempt to commit suicide, relays her tragic story as she told it to him. Next week, we run the true story of Miss Munson's picture, "Heedless Moths," a story that has never been published.

I SOUGHT death because I had no wish to live.

"I am already dead, save for the fact that my body still breathes and blood flows through my veins. But so far as hope or joy or expectation for the future goes, my life is past.

"What is the use of moving about and breathing when all desire for life has ceased? I longed for death and I tried to die. They brought me back to life and now I do not care any more. Whether I live or die, it doesn't matter."

These are the words that Audrey Munson, known a few short years ago as "the world's most perfect model," spoke to a representative of the "Movie Weekly" who called upon her in the humble little cottage in the village of Mexico, where a few days ago she attempted to take her life by swallowing a solution of bichloride of mercury.

The girl is thin almost to emaciation. Her cheeks are hollow, her eyes shine like burning coals from their sockets. Her restless fingers are like claws. So little remains of the Audrey Munson who was the most beautiful of models and the idol of the motion picture world that it is pitiable to trace the resemblance.

The voice which comes from the pale lips, too, is toneless. The girl looks as she might if she lay in her coffin, save for the burning coals of eyes.

"There is a curse on me," she said simply. "There has been a curse upon me for years."

And she believes it—this girl with the face of the dead and the fleshless form and the flashing eyes. And, who knows—it may be true.

"I suppose that I have had everything," she says drearily. "Beauty and admiration and

One of her best poses—as a tambourine girl.

love and fame. But the curse has taken them all away. I am forgotten and cast aside.

"Why didn't I die? Oh, why didn't I die? Perhaps I might have found peace. Now there is neither peace nor rest for me—just the hopelessness of death without the quiet of the grave."

When she was a child, Audrey Munson had her fortune told by a gypsy crone who predicted that by her beauty she should rise to high places in the world and by her beauty she should be cast down.

"You shall be beloved and famous," said the gypsy woman, "But when you think that happiness is yours, its dead sea fruit shall turn to ashes in your mouth.

"You who shall throw away thousands of dollars as a caprice, shall want for a penny. You, who shall mock at love, shall seek love without finding.

"Seven men shall love you. Seven times you shall be led by the man who loves you to the steps of the altar, but never shall you wed."

When Audrey Munson first became an artist's model, she was 14 years old. She had started on the stage in the chorus of a summer show running at the Casino. One day, as she was walking downtown after a rehearsal, she saw a middle-aged man following her and her mother who was with her.

He came up with them and asked whether Audrey might not pose for him for photographic art studies used in magazines. Her mother consented and for more than a year she went several times a week to his studio, posing in Greek and Roman draperies—now as a naiad, now as a dryad, now as a caryatid—as Venus, the goddess of beauty, and as Diana, the goddess of wisdom and war.

Then she was induced to pose for the nude. "After all that I had learned about the beauty of the human form, looked upon in the abstract, it never seemed wrong or improper," she said.

One day her old friend was found dead in his bed. On the day before his death, he had asked his girl model to be his wife. She liked and respected him and had made up her mind to accept the proposal, when he died.

At his studio the girl had met many famous artists, and she decided to seek work as a model. She was employed by A. B. E. Wenzell, Howard Chandler Christy, Irving R. Wiles and other prominent painters and illustrators. She was a favorite model with sculptors and posed for the female figures on the Court of Honor modeled by Isador Konti for the Panama-Pacific Exposition. She was the original of Waineman's "Descending Night" and she sat to Daniel Chester French as "Evangeline." Every studio knew her and her work brought her in thousands of dollars.

Then she went into the movies. She acted in "Inspiration," "Purity" and "Girl of My Dreams." Artists, sculptors and moving picture producers were bidding for her. She went on the stage and posed for art studies and chiefly for her was written "The Fashion Show" that made such a hit at the Palace Theatre.

It was during the run of this feature, Miss Munson says, that the curse fell upon her.

AUDREY MUNSON'S Strange Life

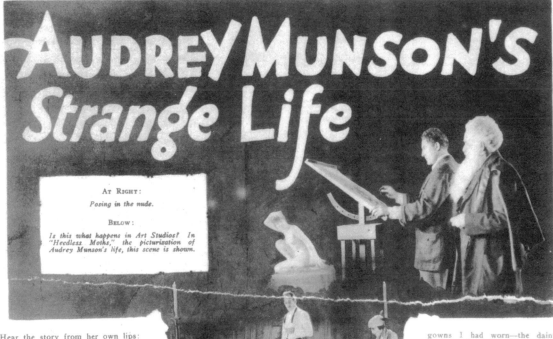

AT RIGHT:

Posing in the nude.

BELOW:

Is this what happens in Art Studios? In "Heedless Moths," the picturization of Audrey Munson's life, this scene is shown.

Hear the story from her own lips:

"It was when I was playing in 'The Fashion Show,'" she said. "A man prominent in the theatrical world came into my dressing room. I was in a bathing suit. He passed his arm around me and pressed his burning lips against my shoulder.

"I struggled to free myself. I struck at him.

"Get away from me!" I cried out. "Don't touch me. I hate you. Your touch is repulsive to me. I would rather have a snake crawl over me than to feel your hand upon me.

"He released his hold.

"'Do you mean what you have just said?' he asked.

"'I do,' I replied defiantly. But even as I spoke I shuddered.

"'You will have cause to remember this,' he said—and left me.

"A few days later I was told that 'The Fashion Show' was to close. I had no explanation. The playlet had been drawing immense houses, but it was closed at almost a moment's notice. Later it was put on again with another to wear the

gowns I had worn—the dainty negligees, the bathing suit and the rest, which they had said no one could wear but me.

"I went everywhere and tried to obtain an engagement on the stage or screen. There was no place for me. Even the studios of the artists and sculptors were closed against me. There were excuses, in the latter case, of course. It was war time. Many painters and sculptors were in France. Those who remained were finding no market for work.

"I offered my services to the Government in an effort to trail down German spies. My offer was accepted, but soon I became conscious that the powers had no confidence in me. I was watched more closely than I tried to watch those whom I was told to shadow.

"Since the death of my old friend who was so good and kind to me, I had had several lovers—men who declared that they were mad about me. Three times I was ready to

(Continued on page 30)

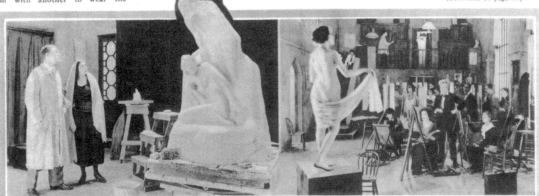

BELOW (AT LEFT):

A scene from "Heedless Moths," showing Miss Munson gazing at an art study for which she posed.

BELOW (AT RIGHT):

Posing for a group of art students in the heyday of her fame.

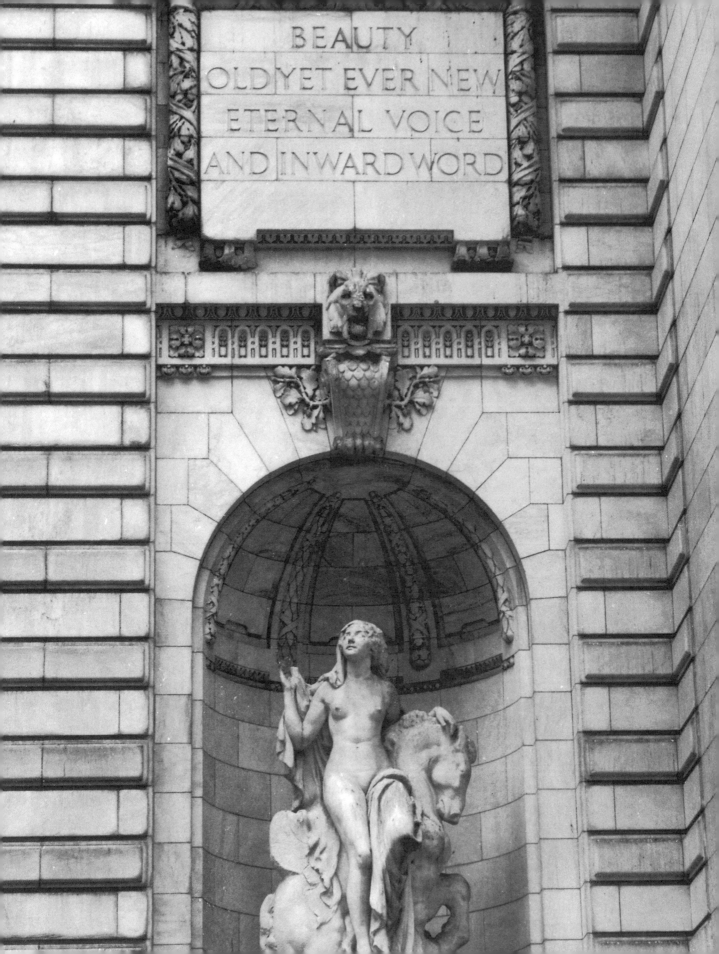

BEAUTY
OLD YET EVER NEW
ETERNAL VOICE
AND INWARD WORD

THE LATER YEARS

1924-1931

✳ *Marlene Dietrich became an overnight star in "The Blue Angel." • Duke Ellington was a hit with his "Mood Indigo," and the Empire State Building was completed. • The "Star Spangled Banner" was declared the national anthem by Congressional decree. • Lindbergh's baby was kidnapped and found dead. • Undershirt sales slumped after Clark Gable revealed he wore none in the film, "It Happened One Night." • On everyone's lips was the popular song "I only Have Eyes for You." • The art world boasted stars named Magritte, Mondrian, Picasso, and Matisse. • Adolf Hitler was named chancellor of Germany. • Bonnie and Clyde were apprehended, meeting their deaths with rounds of automatic ammunition. • "The Gay Divorcee," starring dancing duo Fred Astaire and Ginger Rogers brought audiences to their feet, and enchanting little Shirley Temple became a mega-star...and the Great Depression arrived* ✳

AUDREY, mired in depression and disillusion,
unable to cope, succumbed to a final judgement
of profound consequence.

Tucked away in a tiny hamlet, Audrey gained a different sort of reputation than she had known in her days of glory. It was one that revolved not around her beauty and fame, but rather her mind and her erratic behavior. Her odd displays led local towns-people to call her "Crazy Audrey." Other than checking the post office for letters and walking her dogs, she was seldom seen. A 1924 article in the local paper reports that the beauty whose "career was one of the most colorful of modern times, attracting nationwide attention...has fallen into ill health, and misfortune has set upon her, reducing her to her present condition."

Katherine spoke almost exclusively for Audrey and was her only trusted link with the outside world. She told everyone her daughter was "just nervous" and not "crazy." But when the reporters came around looking for Audrey, Mrs. Munson gave them the bitter truth which they eagerly put into print. "The poor girl feels that the whole world has turned against her...the gang [of film producers] with the money have used her beauty to bring them wealth and she got only $4,000, while four of her pictures are still on the road [making money] today...she should have had $3,000,000 if she got her lawful share..."

Years passed. The Munson women moved from house to house with Katherine working as a domestic. Audrey sank further into a state of mental unbalance. She roamed the fields of the nearby farms, read vora-ciously, wrote movie scripts, and admitted to her mother she heard voices "on the wires" at night. Was paranoia was setting in?

Though the women were no longer dogged by the newspaper reporters whom Audrey had once loved to delight by creat-ing impromptu poses, she was seen by one reporter who knew her in her days of glory. The *Syracuse Post Journal* in 1926 eagerly wrote of Audrey's sad demise: "Her face bares the mark of heartache and disap-pointments, and the figure which won the admiration of the world as it appeared in the work of artists and sculptors of the first rank, in several motion pictures which made record breaking success, is worn and wasted with illness and suffering."

Katherine Munson who, according to Edgar Munson, had put into his daughter's head ideas of acting, dancing, and fame, told all who asked, "We're going to keep fighting for our rights [and the money from the pro-ducers] until we can fight no more."

Coincidentally, between 1926 and 1931, several barns in the area were burnt down in obvious acts of hostility. Because of her unfortunate reputation Audrey was blamed even though the neighbors had not seen her outside in three years. Katherine moved

again and again, hoping to restore her daughter's reputation. She continued to insist that Audrey gave her no trouble and was "just nervous."

In 1931, a local judge took this matter more seriously. Audrey was forced by the court into treatment for a problem that in those times was simply called a "mental blight." Katherine, unable to cope with her job and her daughter's unpredictable behavior, took Audrey to a nearby state psychiatric facility. There, Audrey, at 39 years of age, was committed for treatment.

By her own accounts in later years, Katherine Munson attempted to bring her daughter home, though financial strain and poor health made this impossible. Visits to Audrey became less and less frequent as the ten dollar train trip to the psychiatric facility was often beyond her means. Audrey spent the remaining years of her life there. Visitors were few, and after her father and mother passed away, in 1945 and 1954 respectively, there were almost none. Occasionally a curiosity seeker or journalist attempting to get her story would stop at the hospital. However, Audrey, by choice, saw none. She decided never to tell her story again to anyone who would use her fame for their own gain, rejecting even those supposedly willing to pay. Little by little, Audrey's once dazzling image faded from the public consciousness, into obscurity.

Her odd displays led local townspeople to call her "Crazy Audrey."

129

POSTSCRIPT.

Edgar Munson and his second wife continued to live in Syracuse and raise their five children. After they passed away, less and less was remembered about Audrey. And, as a matter of course, she was never discussed by relatives.

Harold (Hal) Munson, the youngest of Edgar's children, married in the 1940's. After the war, he opened an appliance shop in downtown Syracuse, and started a family of his own.

In the 1950's their daughter, Darlene, recalled overhearing her parents speaking in hushed tones of "Aud." When she asked "whose Aud?" she was told "never mind!" The owner of a gas station down the block from their store told the 8-year-old Darlene he had been in love with her "Aunt Aud," and recalled occasions when the famous model would come to visit in Syracuse. But who was this mysterious "Aunt Aud?" Darlene's parents forbade her to speak of it again.

Years later, at a family dinner, Hal thought out loud, "I wonder whatever happened to Aud?" Darlene, now grown up and with children of her own, had long put the subject out of her mind, but not her heart,

and asked once again for details. Her father finally told the story of his famous half-sister. Darlene was shocked to learn of her aunt's fate. Audrey had been sent to a psychiatric facility many years before. Though Darlene understood the social stigma of "insanity" and "institutionalization," especially in the early part of the 20th century, she could not abide by their choice to reject a member of the family. Audrey was now alive in her mind, the picture of a real person emerging.

This time, her curiosity was not to be controlled. Shortly thereafter, she called the hospital in hopes of obtaining the records of her lost great aunt and perhaps piecing together a few bits about this mysterious woman from long ago. The hospital, understandably, was hesitant to release information until Darlene proved that she, as a relative, was entitled. Soon after, a social worker from the hospital returned her call, and Darlene heard the unbelievable news, "Your Aunt Audrey is still alive."

"She's alive! Aunt Aud is alive?" was all she could say. Her excitement could not be contained. Darlene was compelled by personal conviction to cross the decades and

discover her long lost aunt of childhood fantasies ... face to face. It was her strong feeling of kinship which pushed her until she could gain some recognition from the aged woman she longed to know.

Soon thereafter, Darlene insisted the family visit the psychiatric facility together. Along with her sister, mother and father (who at that time was very ill), they made the several-hour trip to the hospital. Nervously they waited in the reception lounge where they were informed that Audrey seldom had visitors and refused to see her relatives who had abandoned her for so long. Through a social worker, they pleaded with her to at least see her half-brother and his daughter Darlene, who wished her no harm. Audrey reluctantly agreed.

Hal and Darlene awaited the aged woman, knowing her journey was also one across time and emotional barriers though it was, in reality, just a few hundred feet down the corridor. They waited. Then, Audrey was brought into the room. She had long, flowing white hair, attractively coifed, and was dressed neatly in a simple contemporary frock. Despite her advanced age, Darlene

could see the remnants of a very beautiful woman in Audrey's lovely bone structure and her luminous, fine complexion. She bore none of the traces of a person with mental illness. The gift they brought Audrey was a box of her favorite mint candy. She demurely asked Darlene to open the box and graciously offered them all to take the first pieces. After a short while, Audrey agreed to meet Darlene's mother and sister, who waited outside the room, hoping they too would be invited to this extraordinary reunion.

Darlene was overwhelmed by the presence of this woman. After over fifty years of living in a hospital, forgotten by all and pushed cruelly away from the glamorous and exciting life, she showed no signs of bitterness or resentment. Audrey proved to be a charming, gentle woman, and her memory was clear. She asked questions about members of the family. They promised to come back to visit with her again.

Darlene was immediately drawn to this sweet and self-effacing woman. Audrey talked little of her career, and didn't want to be a bother to anyone, once remarking "you don't have to come back if you don't want to."

Later, the family discussed their impressions of Audrey: She did not seem disturbed. She was on no medications and had long been a favorite of the staff of the facility who had deemed her their "resident celebrity." Audrey was never a problem to them; rather, always a joy. Her favorite activity was spending time in the hospital library. Over the years, Audrey inspired respect, causing the staff to be protective of the kind and aging muse whose story they hardly knew.

Darlene and the family continued to visit Audrey when they could, always checking to see if she needed anything, taking her gifts of candy and the cuddly stuffed animals Audrey loved. On occasion, Darlene would bring her young sons. Audrey kept pictures of her grand nephews in her room and told Darlene she kissed the two small photos every night before she went to bed.

In 1991 when Audrey celebrated her 100th birthday, a party was given for her by the hospital. All her recently acquired family gathered at the hospital to help her celebrate. Audrey sang the old songs she so dearly loved and delighted at having an audience. She knew all the words and sang in perfect pitch. They enjoyed cake and Audrey received many presents from the adoring hospital staff. They presented her with a lap full of soft kittens for the afternoon. Actually, Audrey had requested a ride in a jet airplane and a bottle of wine, but they were not able to accommodate these spirited requests. When Darlene and her sister asked Audrey if she might pose for pictures, she said, "Of course!" and when she saw the lens pointed at her, Audrey's face lit up, she cocked her head so naturally and struck a fine pose. The muse within was still alive.

She had spent 65 years of her life in the protected environment of the psychiatric facility. Just 100 miles from her place of birth, and only 400 miles from New York City, where scores of likenesses of the mysterious muse still stand, on February 20, 1996, Audrey passed quietly away at the astonishing age of 105.

AUDREY MARIE MUNSON
1891-1996

ARTISTS' PROFILES

AITKEN, ROBERT INGERSOLL
(1878-1949)

EDUCATION: Mark Hopkins Institute, San Francisco

WORKS: Monument to McKinley, Golden Gate Park, San Francisco; "The Flame," Metropolitan Museum of Art, New York City; pediments for the United States Supreme Court and the National Archives buildings in Washington D.C.; "Bacchante," Baltimore Museum of Art, Maryland.

Robert Aitken was born in San Francisco. He opened his own studio at the remarkable age of eighteen and later, opened a studio in Paris. He relocated in 1907 to New York and joined the flourishing Beaux Arts movement. Working in bronze, stone and figurative medals his heroic and colossal work showed the influence of the classics particularly the muscular style of artists such as Michelangelo.

BITTER, KARL
(1867-1915)

EDUCATION: Vienna School of Applied Arts, Academy of Fine Arts Vienna

WORKS: Palace Hotel, New York City; Vanderbilt Estate in North Carolina; Caryatids and portrait medallions on the Metropolitan Museum of Art building, New York City; bronze gates Trinity Church, New York City.

Born in Vienna, Bitter began his early career in stone cutting which led to a further education in fine arts in his native country. A man of tenacious energy, strong opinions, and diverse capacities, he was named director of sculpture at the Columbia, St Louis, and San Francisco Expositions.

CALDER, A. STERLING
(1870-1945)

EDUCATION: Pennsylvania Academy of Fine Arts, studying under Thomas Eakins; Academie Julian and Ecole des Beaux-Arts, Paris

WORKS: "Star Maiden;" The Fountain of Energy at the PPIE; the Depew Fountain in Indianapolis; statue of George Washington for New York City's Washington Square Arch; Swann Memorial Fountain, Philadelphia.

Calder taught art at the National Academy of Design and the Art Students League in New York. He served as chief sculptor of the P.P.I.E. overseeing works submitted by an elite group of sculptors from New York City—all members of the prestigious National Sculpture Society. His "Star Maiden" was considered by some to be the symbol of the Exposition as it was reproduced 133 times. His son, the mobilist, Alexander Calder, became one of the great contemporary American sculptors.

French, Daniel Chester
(1850-1931)

EDUCATION: Jean Antionin Mercie in France, studied with Thomas Ball in Florence.

WORKS: "Minute Man" and Milmore Memorial, Concord, Massachusetts; "Memory," Metropolitan Museum of Art, New York City; Lincoln Memorial, Washington D.C.; "Republic," Columbia University, New York; Hunt Memorial, New York City; doors Boston Public Library; "In Flanders Fields," Milton, Massachusetts

Born at Exeter, New Hampshire and raised in Concord, Massachusetts, French's early education in the arts in America led to study overseas, influencing his style of classic figurative sculpture and fluid lines. A student of Augustus Saint Gaudens, he is best known for his monumental Lincoln Memorial in Washington D.C.. The quintessential "gentleman artist," French is perhaps the most familiar of American Beaux Arts sculptors. His studio, Chesterwood, is the only remaining studio from this period and, as a property of the National Trust, is open summers to the public.

Konti, Isidor
(1862-1938)

EDUCATION: Imperial Academy Vienna

WORKS: "Genius of Immortality," Metropolitan Museum of Art, New York City; "South America," Bureau of American Republics Building, Washington D.C.; Kit Carson Memorial, National Museum of Art, Washington D.C.; "Pomona," New York City; "Column of Progress," Panama Pacific International Exposition, San Francisco

Immigrating from his native Vienna at the age of 29, Konti had previously studied in Rome, where the influence of the Renaissance was to inspire his charming and fanciful work. One of the more decorative of the Beaux Arts talents, Konti came to work in the New York studio of his fellow Austrian Karl Bitter, remaining friends and collaborators until Bitter's death.

LONGMAN, EVELYN BEATRICE
(1874-1954)

EDUCATION: Art Institute of Chicago, apprenticeship with D.C. French in New York

WORKS: Bronze door of U.S. Naval Academy, Annapolis, Maryland; bronze door of library at Wellesley College; "Victory," Metropolitan Museum of Art, New York City; Consecration, Wadsworth Athenaeum, Hartford, Connecticut.

Born Winchester, Ohio. Longman pursued the study of art in evening classes at the Art Institute of Chicago, later working in the studio of Isidor Konti, in New York. She also served an apprenticeship with Daniel Chester French. In 1920 she married Nathaniel Horton Batchelder. Together they lived and taught at the Loomis Chaffee School in Windsor, Connecticut.

PICCIRILLI, ATTILIO
(1866-1945)

EDUCATION: Academia de San Luca, Rome
WORKS: Facade of the Brooklyn Museum, New York City; glass relief over doors of the Palazzo d'Italia, Rockefeller Plaza, New York City; "Frangilina", Metropolitan Museum of Art, New York City; Wisconsin State Building decorations; Maine monument, Columbus Circle, New York City; Pulitzer memorial.

The eldest son of an Italian stone cutter, Attilio was part of a large and amazingly talented family who immigrated to the United states in 1888. Maintaining a European tradition of working together as a group, Attilio, his five brothers and their father Guiseppe, established a marble cutting studio in the Bronx which not only carried out the designs of other notable artists, but also received commissions of their own.

WEINMAN, ADOLPH ALEXANDER
(1870-1952)

WORKS: Municipal Building Archway Relief, New York City; "Night" and "Day" Penn Station, New York City 1910; Walking Liberty Half-Dollar and Mercury Dime 1916; "The Rising Sun" Panama Pacific International Exposition, San Francisco 1915.

Born in Germany and brought to New York in 1880, Weinman's early education in Manhattan included Cooper Union and the Art Student's League where he came to the attention of Augustus Saint Gaudens with whom he apprenticed, and later served as director of his studio. He also worked with Charles Niehaus and Daniel Chester French, most notably on the figures on the New York Custom House in 1897. In 1904 he opened his own studio gaining the commission of the now demolished

Pennsylvania Station. A reputation for excellence in detailed sculptural portraiture led to prestigious commissions in medals and coins, and many prominent works in bas relief such as the murals at the Municipal Building in New York City.

WHITNEY, GERTRUDE VANDERBILT (1877-1942)

EDUCATION: Brearly School, New York City; Art Students League; Andrew O'Connor studio in Paris

WORKS: "Head of a Spanish Peasant" Metropolitan Museum of Art, New York City; Titanic Memorial, Washington D.C.; "Red Cross," Musée des Invalides, Paris; War memorial, Washington Heights, New York City; "Buffalo Bill Cody," Wyoming; "Peter Stuyvesant," Stuyvesant Square, New York City; "Caryatid" Brookgreen Gardens, South Carolina.

Receiving her primary education from private tutors, the young Gertrude began her serious sculpture career after her marriage to another member of American aristocracy, Harry Payne Whitney. Gertrude was often caught between the disdain of her family for her bohemian ways, and the criticism of a public who could not envision a wealthy socialite as a legitimate artist. Perhaps her greatest contribution to art was her founding of the Whitney Studio Club which later became the prestigious Whitney Museum of American Art.

Note: Audrey Munson also posed for numerous other artists working in a variety of media including paintings, tapestries, prints, illustrations, coins, jewelry and precious metal, and small decorative and functional art pieces which are not included in this book.

ELATED READING

All the World's A Fair by Robert W. Rydell (University of Chicago Press 1984)

An Art Lovers Guide to the Exposition by Sheldon Cheney (Berkeley University Press 1915)

Attilio Piccirilli: Life of an American Sculptor by Lombardo (Sir Isaac Pittman & Sons Publishers) 1942

Brookgreen Gardens by Beatrice Gilman Proske (Private Printing 1968)

Gertrude Vanderbilt Whitney by B.H. Freidman (Doubleday 1978)

Hollywood: The Pioneers by Kevin Brownlow

In My Life by Arnold Genthe (Reynal & Hitchcock 1936)

Karl Bitter: A Biography by Scheville (Chicago Press 1917)

Lost Films by Fredrick Thompson (1972)

Masters of American Sculpture by Donald Martin Reynolds

Memories of a Sculptor's Wife by Mary French (Riverside Press 1928)

Monuments and Masterpieces by Donald Martin Reynolds (Thames & Hudson 1988)

Movies in the Age of Innocence by Edward Wagenknect (University of Oklahoma 1962)

Panama Pacific Exposition by Stella G.S. Perry (Paul Elder & Co. 1915)

Public Sculpture and Civic Ideal in New York 1890-1930 by Michelle Bogart. (Smithsonian Institution Press 1997)

Rediscovering American Sculpture: Studio Works 1893-1939 by Jannie Connor & Rosencrantz

San Francisco Invites the World: San Francisco's Panama Pacific Exposition of 1915 by Peter Clute and Donna Ewald (Chronicle Books 1991)

Shaping the City by Gregory F. Gilmartin (Clarkson Potter 1995)

The Anthropology of Worlds Fairs: San Francisco Panama Pacific Expo by Burton Benedict w/ Miriam Dobkin (Scholar Press 1983)

The Sculpture and Mural Decorations of the Exposition by A. Sterling Calder (Paul Elder & Company 1915)

The Silent Partner by Timothy Lyons (Temple University Press)

The Story of the Exposition: Being the Official History of the International Exposition by Frank Morton Todd (G.P. Putnam 1921)

ACKNOWLEDGMENTS

To Kevin Hynes, for his endless support.

To Richard Gottehrer, for his infinite patience.

The following individuals and institutions have contributed to this project in many crucial ways. We wish to thank them for allowing us to represent their ideas, remembrances, artifacts and collections within the pages of this book:

Darlene Bradley

Kevin Brownlow

Barbara Dix - County Historical Society, Oswego, New York

Cheryl Drasin

Donna Ewald - The Land of Make Believe

Neal Graffy - Photographic Collection

Christopher Gow - Early 20th Century Sculpture, Sotheby's, New York

Clifford Harrington - Harry Ranson Research Library, University of Texas, Austin

Judy Haven - Onodago Historical Society, New York

Richard & Lydia Kaeyer - nephew of sculptor Isidor Konti

Bill Lane

Gen. James Munson - The Munson Foundation

Andrew Nagle

Nancy Searles - New Haven Historical Society, New York

Bonnie Shamway - Historical Society, Mexico, New York

Wanda Styka - Chesterwood, National Trust for Historic Preservation

Sunset magazine

Mary M. Tahan - Literary Agent, Clausen, Mayes & Tahan

Edwin W. Thanhouser

Theyer Tolles - The Metropolitan Museum of Art, New York

Laura Vookles - Curator, Hudson River Museum

Robert Weinman - son of sculptor Adolph A. Weinman

Justin D. White - Photographic Collection

Donald R. Williams - Woodlawn Cemetery, New York

Susie Woods

Special recognition:

The Munson Family Archives and Collection

ESEARCH INSTITUTIONS

American Numismatic Society, New York

Archives of American Art, Smithsonian
Museum

Central Park Conservancy, New York

Chesterwood (Stockbridge, MA), A National
Trust for Historic Preservation Historic Site.

Corbis, New York City

County Historians Association of New York

The Frick Collection, New York

Hudson River Museum, Yonkers, New York

Library of Congress

Metropolitan Museum of Art, New York

Municipal Art Society, New York

The Munson Foundation, Falmouth,
Massachusetts

National Sculpture Society

New York Historical Society

New York Library for the Performing Arts

New York Public Library

Onandaga Historical Association

Santa Barbara Historical Society

Syracuse Public Library

Wolfsonian Museum, Florida International
University, Miami, Florida

ILLUSTRATION CREDITS

PHOTOGRAPHIC

Diane Rozas, photographer: Front cover bottom right, 5, 11, 15, 16, 19, 22, 23, 24, 28, 29, 30, 31L, 32, 33, 35, 36/7, 38, 39, 43, 45, 46, 47, 49, 50, 51, 52, 53, 55, 59, 71 (EVE), 98, 101, 105, 108/9, 113, 114, 120, 126

Justin D. White Photographic Collection: 1, 12, 14, 18, 20, 29, 56, 60, 76

Neal P. Graffy Photographic Collection: Front cover upper left, 6, 7, 8, 15, 79, 82, 85, 86, 87, 90, 102

Donna Ewald Photographic Collection, The Land of Make Believe, Larkspur, CA: Back cover, 64

Brookgreen Gardens -"Maidenhood" - Sherry Fry, sculptor, Brookgreen Gardens Photograph, Pawley's Island, SC: 121

Michele H. Bogart - Photographer: 31 (Overall Image, Maine Monument)

The Munson Foundation
Falmouth, MA: 133

The Mitchell Wolfson Jr. Collection -The Wolfsonian-Florida International University, Miami Beach, FL: 74

The New York Public Library for the Performing Arts, Billy Rose Theater Collection, Astor, Lenox and Tilden Foundations: 3, 80, 89

NEWSPAPERS, JOURNALS, BOOKS

The New York Public Library, General Research Division, Astor, Lenox and Tilden Foundations: 27 and excerpts

Harry Ransom Humanities Research Center; The University of Texas at Austin: New York American, 1913, 1921). 41, 42, 110, 111, 116, 117 and excerpts

The Munson Family Archives & Collection: Various information - excerpts from newspaper clippings (Sources Unidentified) - writings of Audrey Munson, letters of Katherine Mahaney Munson and Edgar Munson. Personal family records pertaining to Audrey. Illustrations on 91, 95, 128

San Francisco Chronicle - 1915: 67 and excerpts

New York American (Hearst) - 1913, 1921: 41, 42, 110, 111, 116, 117 and excepts

Syracuse Herald: excerpts from 1915, 1917,1921, 1922 (Possibly Unidentified Clips on 95, 129)

Sunset magazine - Sunset Publishing Corporation: 78 (*Sunset* magazine, Oct.1915)

Neal P. Graffy Collection: The Sculpture and Mural Decorations of the Exposition - Excerpted Visuals (Publ.: Paul Elder & Company, San Francisco 1915) - Exposition Art, Cardinell/Vincent Co: 63 (Alone), 65, 66, 68, 69, 71 (Genius of Creation), 72, 73, 75

Justin D. White Collection: *Movie Weekly* magazine, 1922: 123, 124, 125, back flap and excerpts

Ann Gray Collection: 63 (Postcard)

Public Collections

The Art Commission of the City of New York:
 Civic Fame
 Spirit (or Pride) of Commerce
 Beauty

State of New York:
 Peace, Appellate Court House
 America, Asia, and Europe, U. S. Custom
 House Building

The Brooklyn Museum, Brooklyn, New York:
 Manhattan
 Brooklyn

Dept. of Parks and Recreation of the City of
New York:
 Strauss (Titanic) Memorial
 Firemen's Memorial
 Maine Monument
 Pomona

Congress Park, Saratoga, New York:
 Trask Memorial

U.S. Mint (A.A. Weinman, Designer):
 Mercury Dime of 1916
 Walking Liberty Half Dollar of 1916

Private Collections

Wadsworth Athenaeum, Hartford, CT.
 Consecration - Gift of James Janius Goodwin

Justin D. White - Collection:
 Audrey's Glass Souvenir of 1901

The New York Metropolitan Museum of Art:
 Memory
 Descending Night
 Victory Mourning

Brookgreen Gardens, Pawleys Island, S.C.:
 Maidenhood

Chesterwood, Stockbridge, MA. - National
Trust for Historic Preservation:
 D.C. French's Studio
 Memory
 Audrey - Study for Head of Brooklyn
 Eve
 Music of Water
 Genius of Creation

Woodlawn Cemetery, Bronx, New York:
 Bronze Doors
 Fortitude

Collection, The Hudson River Museum, Gift of
Mr. Richard Kaeyer - 17.153
 The Three Muses

Mitchell Wolfson Jr. Collection, The
Wolfsonian Florida International University,
Miami, Beach, Florida:
 Star Maiden

Donna Ewald - The Land of Make Believe,
Larkspur CA:
 Official P.P.I.E. Medallion

Hudson River Museum Collection,
Yonkers, N.Y.:
Three Muses

Church of the Ascension, New York City
 Angels - Stained Glass Window

THE AUTHORS

Diane Rozas exhibits her fine art photography in Los Angeles galleries and has her work in numerous private collections. As an advertising copywriter, she works on both the East and West coasts. In addition to authoring seven books in the field of cooking and entertaining, she is a former contributing editor to *Cooking Light* magazine.

Born in Southern California, Anita Bourne Gottehrer followed an education in fine art with a career in the entertainment business. Now based in New York, she manages a music publishing and production company.